Mrs Reynolds and The Ruffian
by Gary Owen

First performed at Watford Palace Theatre from
15 April to 8 May 2010

Cast (in order of appearance)

Cassie	**Annie Hemingway**
Jay	**Morgan Watkins**
Mrs Reynolds	**Trudie Goodwin**
Kieran	**Ricci McLeod**
Mel	**Suzie McGrath**

Director	**Brigid Larmour**
Designer	**Ruari Murchison**
Lighting Designer	**Mark Jonathan**
Sound Designer	**Adrienne Quartly**
Audio Visual Designer	**Dominic Martin**
Casting Director	**Louis Hammond**
Deputy Stage Manager	**Emma Hansford**
Assistant Stage Manager	**Ian Grigson**
Wardrobe Assistant	**Sarah Godwin**
Assistant Director	**Antonio Ferrara**
	(on placement from Birkbeck College)
Wardrobe Work Experience	**Hazel Morris**
	(on placement from Guildhall)

Thanks to the following for their help with this production:

Keir French at Auto Mobility Concepts Ltd
Clements Furniture, TJ Hughes
Alexandra Kelly
Megan Doherty

Author's Note

This play owes much to a number of different sources.
First, To Kill A Mockingbird by Harper Lee gave me the germ
of a story: an encounter between an old lady and a young
boy, which means very different things to each of them.

Second, Camila Batmanghelidjh's brilliant and disturbing book
'Shattered Lives' taught me something of the damage that can
be done to children by persistent abuse and neglect, and
raised the possibility that such damage might eventually be
healed.

Third, Professor Peter Raynor of the University of Wales,
Swansea talked to me about restorative justice, and pointed
me towards a wealth of research material on such schemes
around the world. I drew in detail on Lawrence W. Sherman
and Heather Strang's report for the Smith Institute, 'Restorative
Justice: the evidence'. It's worth saying that while the restorative
justice process in this play is based on actual schemes, the
ways that both Jay and Mrs Reynolds abuse the process should
be taken as examples of dramatic licence. I certainly don't
mean to suggest that actual restorative justice schemes lay their
participants open to being similarly manipulated.

Finally, this play owes most of all to the young people of the
Prince's Trust XL Group at Pethybridge Youth Centre, and the
young people of Sherman Cymru's Acting Out group, both of
which are in Cardiff. They are the inspiration for everything that
is good and brave and hopeful about Jay, and this play is for
them.

Gary Owen
March 2010

Cast

Trudie Goodwin

Trudie is best known for her role as Sergeant June Ackland in ITV's The Bill, which she starred in up until 2007. Other television includes Heartbeat (ITV); Three Up, Two Down (BBC) and appearing in Countdown's Dictionary Corner.

Theatre credits include That Old Feeling (The Mill at Sonning); The Naked Truth (National Tour); Crusade (Theatre Royal Stratford East); I Do Like To Be (Tricycle Theatre); Twelfth Night (Swan Theatre, Worcester); The Beggar's Opera (Lyric Hammersmith); Godspell (Young Vic); Drink The Mercury, The Entertainer, Loot and Merchant Of Venice (all Phoenix Theatre).

Annie Hemingway

Annie trained at RADA. Her theatre credits include: Breakfast At Tiffany's (Theatre Royal Haymarket); Chauntecleer and Pertelotte (The Hen and Chickens Theatre); She Stoops To Conquer (Birmingham Rep and Tour) and Baghdad Wedding (Royal Court Theatre). Theatre whilst at RADA includes: Ghosts; Titus Andronicus; Odysseus and The Duchess Of Malfi.

Other experience includes: Kamikaze Handbook (BBC Radio 4); Chorus In Murder (National Youth Theatre) and Peter Pan and Nuts (Bath Young People's Theatre).

Suzie McGrath

Suzie trained at East 15 Acting School. Theatre whilst training includes: the title role in Dark Lady of the Sonnets; Lady Macbeth; Ronnie in Fallout and the title role in Little Nell. Since graduating, Suzie has worked on readings and short projects with: The Royal Court; Young Vic; Bush Theatre; Oval House Theatre; Soho Theatre and Drywrite.

Theatre credits include: Hive 9 (ICT); When Cheryl Was Brassic (nabokov); Crazy Love (Paines Plough and Oran Mor) and Tracy Beaker Gets Real (Nottingham Playhouse).
Television includes: Eastenders (BBC) and Law and Order: UK (Kudos). Suzie is best known for her role as Keisha in Eastenders, and can be seen in the role of Darla in Law and Order: UK later on in 2010.

Ricci McLeod

Ricci's theatre credits include: Monster Under The Bed (Polka Theatre); Family Man (Theatre Royal Stratford East); Gone Too Far and Catch (The Royal Court Theatre) and Two Step (Almeida Theatre).
Television credits include: Holby Blue, Doctors, Holby/Casualty special (BBC); The Bill (Talkback Thames); Dub Plate Drama (Red Mullet); Ghost Squad (Company Pictures); Green Wing (Tiger Aspect) and 3 series of William & Mary (Granada TV).
Film credits include: Incendiary (Film 4); 7 Lives (Starfish Films) and The Football Factory (Vertigo Films)
Radio credits include: Avoid London (BBC).

Morgan Watkins

Morgan trained at RADA.
Theatre credits include: Mother Courage (National Theatre).
Theatre whilst training includes: Poppy; The Three Sisters; Boxergirl; Love For Love; Iago in Othello and Oedipus in Oedipus The King.
Television includes Peep Show (Channel 4) and The Boys Who Killed Stephen Lawrence (BBC).

Writer Gary Owen

Gary's plays include Crazy Gary's Mobile Disco (Paines Plough and Sgript Cymru), The Shadow of a Boy (National Theatre: winner of the George Devine and Meyer Whitworth Awards), The Drowned World (Paines Plough: winner of the Pearson Best Play Award and a Fringe First), A Christmas Carol (adaptation for Sherman Cymru) and for Watford Palace Theatre, We That Are Left. He is currently writing new plays for National Theatre Wales and the National Theatre of Scotland.

Director Brigid Larmour

Brigid Larmour has been Artistic Director and Chief Executive of Watford Palace Theatre for four years, directing Gary Owen's We That Are Left, Shakespeare's As You Like It, Alan Ayckbourn's Absent Friends and Charlotte Keatley's My Mother Said I Never Should. Brigid is a producer, director, dramaturg and teacher with experience in the subsidised and commercial theatre and television. Between 1998 and 2006 she was Artistic Director of West End company Act Productions, and adviser to BBC4 Plays. From 1993-98 she directed a series of promenade Shakespeares, Shakespeare Unplugged, for RNT Education. From 1989 to 1994 she was Artistic Director of Contact Theatre, Manchester, commissioning the first British plays responding to the rave scene (Excess/XS), and the implications of virtual reality (Strange Attractors, a multi-media promenade production, by Manchester poet Kevin Fegan). She trained at the RSC, and as a studio director at Granada TV.

Designer Ruari Murchison

Ruari has designed productions in Helsinki (Finland). Washington DC, The Stratford Festival (Canada), Stuttgart (Germany), Luzern (Switzerland), Haarlem (Holland), Elisnore (Denmark) and many regional theatres in the United Kingdom.
Recent design credits include: Mappa Mundi, Frozen, The Waiting Room, The Red Balloon (National Theatre); Titus Andronicus (Royal Shakespeare Company);Othello (Trafalgar Studios); The Solid Gold Cadillac (Garrick); A Busy Day (Lyric Theatre, Shaftsbury Avenue); Peggy Sue Got Married (Shaftsbury Theatre); The Snowman (Peacock Theatre) Toyer (Arts); The Three Sisters on Hope Street, The Glass Room, Gone to L.A. (Hampstead Theatre); Henry IV parts I and II (Washington Shakespeare Company, USA); West Side Story, The Sound of Music (Stratford Festival, Canada); Hamlet (Elisnore, Denmark); Macbeth, Medea, The Lion, the Witch and the Wardrobe, Othello, The Secret Garden, (West Yorkshire Playhouse); The Threepenny Opera, An Enemy of the People (Theatr Clwyd);

Cling to me like Ivy, Uncle Vanya, A Doll's House, The David Hare Trilogy- (Racing Demon, Absence of War, Murmuring Judges) TMA Best Design Nomination 2003, The Tempest, Macbeth, Hamlet, His Dark Materials,(Birmingham Repertory Theatre); Intemperance, Tartuffe (Everyman and Playhouse Theatres, Liverpool). Copenhagen, Alfie (Watford Palace Theatre).

Opera credits include: Der Freischutz (Finnish National Opera); Peter Grimes, Cosi fan Tutte (Luzerner Opera, Switzerland); La Cenerentola, Il Barbiere di Siviglia (Garsington); L'Italiana in Algeri (Buxton); Les Pelerins de la Mecque, ZaZa (Wexford).

Ballet credits include: Bruise Blood (Shobana Jeyasingh Dance Company), Landschaft und Erinnerung (Stuttgart Ballet, Germany); The Protecting Veil (Birmingham Royal Ballet).

Lighting Designer Mark Jonathan

Mark has designed extensively in theatre and musicals since he lit his first musical at Watford in 1979 and more recently Paradise Lost, My Mother Said I Never Should and Cinderella. His designs have been seen at many of the country's regional theatres as well as the National Theatre, where he was head of lighting from 1993-2003, the RSC, the West End and Broadway. His lighting for Prometheus Bound in New York was nominated for the Drama Desk award for outstanding lighting.

He has designed for many of the world's leading opera and ballet companies including Los Angeles Opera, Bavarian State Opera, Washington National Opera, Finnish National Opera, Spoleto Festival, Scottish Opera, Vlaamse Opera, Israeli Opera, Opera Du Rhin, Potsdam, Holland Park, Glyndebourne, The Royal Ballet, BRB, NBT, London Children's Ballet, American Ballet Theatre, Ballet Capitole de Toulouse, Staatsballett Berlin, Stuttgart Ballett, Japanese National Ballet. www.markjonathan.com

Sound Designer Adrienne Quartly

Theatre includes: My Zinc Bed (Royal and Derngate, Northampton); The Grand Guignol (Drum Plymouth); The Fastest Clock in the Universe (Hampstead); The Container (Young Vic); Here Lies Mary Spindler, The Tragedy of Thomas Hobbes (Royal Shakespeare Company); 365 (National Theatre of Scotland); 93.2FM (Royal Court Theatre); Woyzeck (St Ann's Warehouse, New York); Private Fears and Public Places, Just Between Ourselves (Royal and Derngate, Northampton); ; My Real War, Trafalgar Studios; Small Change, (Sherman Cymru); Lighter Than Air (National Tour 2010); Hysteria (Inspector Sands); Torn, An Enemy of the People, Silver Birch House, (Arcola Theatre, London); The Last Waltz Season (Oxford Stage Company); Amedee (Young Vic); A Touch of the Sun (Salisbury Playhouse/Yvonne Arnaud Theatre, Guildford);

Tejas Verdes, Woyzeck (The Gate Theatre); Playing For Time, A Touch of the Sun (Salisbury Playhouse); Lucy Porter: Lady Luck (Assembly Rooms, Edinburgh); Mercy Fine (Clean Break Theatre Company); 3 Women, Jarman Garden (Riverside Studios); Hideaway (Edinburgh); Forgotten Voices (Southwark Playhouse); Attempts On Her Life (BAC); Inflated Ideas (Riverside Studios).
Composer on Tragedy of Thomas Hobbes (RSC), Lighter than Air (Edinburgh 09), A Christmas Carol (Sherman Cymru), Faustus/School for Scandal, Volpone/Duchess of Malfi (Greenwich/Stage on Screen)
www.adriennequartly.com

Audio Visual Designer Dominic Martin

Dom graduated from Bretton Hall (2000) in Theatre Design and Technology, and is a freelance Designer and Video Artist specialising in VJ'ing, Sampling and New Technology. Dom returns to Watford Palace Theatre, having previously designed AV for 'Top Girls' (2006).
Dom Co-founded Physical Theatre/New Technology company 7K and toured its work internationally.
Dom has also toured nationally and internationally as a Production/ Technical Manager for Jasmin Vardimon Dance Company, Bonachela Dance Company, Vincent Dance Company, Sulayman Al Bassam Theatre Company and theatres including The Royal Opera House and the Institute Of Contemporary Art (ICA).
Dom co-founded Blueboxx Creative, a specialist Theatre and Events equipment hire company, which is based at Elstree Film Studios.

Casting Director Louis Hammond

Recent theatre includes: All My Sons (the Curve, Leicester); Caryl Churchill season, international residencies, Rough Cuts, Fiftieth Anniversary season (Royal Court); Othello (Glasgow Citizens); The Indian Wants the Bronx (Young Vic); Loot, directed by Sean Holmes (Tricycle); Blowing Whistles (Leicester Square Theatre); Absent Friends directed by Brigid Larmour (Watford Palace); Dirty Butterfly (Young Vic), directed by Michael Longhurst; Testing the Echo by David Edgar, directed by Matthew Dunster (tour/Tricycle); The Importance of Being Earnest, directed by Peter Gill (national tour/Vaudeville); The Member of the Wedding, directed by Matthew Dunster (Young Vic); The Dumb Waiter, directed by Harry Burton (Trafalgar Studios); Donkeys' Years, directed by Jeremy Sams (national tour); Rock'n'Roll by Tom Stoppard, directed by TrevorNunn (Royal Court/Duke of York's); Jus' Like That, directed by Simon Callow (Garrick Theatre).
Television includes: Head of Casting at The Bill (Thames Television).
Films include: Arsene Lupin, Ne Quittez Pas, Beyond Re-Animator and Mirrormask.

Watford Palace Theatre...

is a local theatre with a national reputation.

The creative hub at the heart of Watford, the Palace engages people through commissioning, creating and presenting high-quality theatre, and developing audiences, artists and communities through exciting opportunities to participate.

Contributing to the identity of Watford and Hertfordshire, the Palace enriches people's lives, increases pride in the town, and raises the profile of the area through its work.

The quality of work on stage and beyond is central to the Theatre's ethos. Recently, the Palace has enjoyed critical acclaim for its productions of Neil Simon's **Brighton Beach Memoirs** (2010) and Charlotte Keatley's **My Mother Said I Never Should** (2009).

Work created at Watford Palace Theatre regularly tours nationally and recent collaborations include co-productions of **Street Scene** with the Opera Group and the Young Vic, which won the Evening Standard award for Best Musical, **Stickman** with Scamp which toured internationally and played at London's Soho Theatre and **Tintin** with the Young Vic, which toured nationally before transferring to the West End.

The Palace has commissioned and is developing plays with a range of exciting writers including Gary Owen's **Mrs Reynolds and the Ruffian** (2010) and Tanika Gupta's **Great Expectations** (2011) set in nineteenth century India.

Community partnerships have led to the success of projects such as **Milestones** (2008) and **Hello, Mister Capello** (2010) both bringing together the creativity of Watford's diverse local communities.

These build on the year-round programme of Palace and Hertfordshire County Youth Theatres, adult workshops, backstage tours, community choir and extensive work with local schools.

The beautiful 600-seat Edwardian Palace Theatre is a Grade II listed building. Refurbished in 2004, the Theatre offers modern and accessible facilities including its own rehearsal room and wardrobe and scenic workshop. Recently the Theatre opened the new Green Room Bar and continues to develop the quality of experience for the tens of thousands of people visiting the Theatre each year.

A year in numbers...

- Reaching a total of 150,000 people

- Over 16,000 participatory sessions

- A season brochure goes to 80,000 customers

- 115,000 unique website visits

- A pantomime attended by over 25,000 visitors

- Visits generate over £1m of spending in the local economy

- Over 250 performances

- More than a dozen productions produced or co-produced

Creative Associates

Watford Palace Theatre extends the ambition and reach of its work through partnership projects and by offering developmental resources to the following Creative Associates:

Charlotte Keatley, an internationally acclaimed playwright best known for her hit play My Mother Said I Never Should

Gary Owen, an award-winning playwright whose work has been successfully produced at Watford Palace Theatre

Indhu Rubasingham, who has directed for the National Theatre and Royal Court

Kate Flatt, an acclaimed international choreographer living in Watford and working around the world

nabokov, a new writing theatre company from the Eastern region

The Opera Group, producing and touring quality music theatre and opera

Rifco Arts, a theatre company producing new writing celebrating British Asian culture

Scamp Theatre, producers for the Eastern region specialising in work for young people

Stacey Gregg, an emerging young playwright with a distinctive voice

Time and Place

Somewhere in Britain. The Present.

Act One

1 An interview room - early Spring
2 Mrs Reynolds' front garden - a few days later
3 The end of the street - the next day
4 The end of the street - the next day
5 The end of the street - later that day
6 The end of the street - the next day
7 Mrs Reynolds' front garden - the next day

Act Two

1 The end of the street - Summer
2 Mrs Reynolds' front garden - Autumn
3 Mel's garden - later that day
4 The end of the street - later that evening
5 The end of the street - the next day
6 Mrs Reynolds' front garden - early December
7 Mrs Reynolds' living room - late December
8 The end of the street - later that evening
9 Mrs Reynolds' living room - a few weeks later
10 The end of the street - Spring

This play contains strong language.

If you are affected by any of the issues in this play you can
seek support or find out about services available
to you by calling SupportLine on 01708 765200.

MRS REYNOLDS AND THE RUFFIAN

Gary Owen

MRS REYNOLDS AND THE RUFFIAN

OBERON BOOKS
LONDON

WWW.OBERONBOOKS.COM

First published in 2010 by Oberon Books Ltd
521 Caledonian Road, London N7 9RH
Tel: 020 7607 3637 / Fax: 020 7607 3629
e-mail: info@oberonbooks.com
www.oberonbooks.com

A catalogue record for this book is available from the British
Library.

PB ISBN: 9781849430654
E ISBN: 9781849438780

Cover image by Cog Design

Acknowledgements

This play owes much to a number of different sources.

First, *To Kill A Mockingbird* by Harper Lee gave me the germ of a story: an encounter between an old lady and a young boy, which means very different things to each of them.

Second, Camila Batmanghelidgh's brilliant and disturbing *Shattered Lives* taught me something of the damage that can be done to children by persistent abuse and neglect, and raised the possibility that such damage might eventually be healed.

Third, Professor Peter Raynor of University of Wales Swansea talked to me about restorative justice, and pointed me towards a wealth of research material on restorative justice schemes around the world. I drew in detail on Lawrence W. Sherman and Heather Strang's report for the Smith Institute, 'Restorative Justice: the evidence'. It's worth saying that while the restorative justice process in this play is based on actual restorative justice schemes, the ways that both Jay and Mrs Reynolds abuse the process should be taken as examples of dramatic licence. I certainly don't mean to suggest that actual restorative justice schemes lay their participants open to being similarly manipulated.

Finally, this play owes most of all to the young people of the Prince's Trust XL Group at Pethybridge Youth Centre, and the young people of Sherman Cymru's Acting Out group, both of which are in Cardiff. They are the inspiration for everything that is good and brave and hopeful about Jay, and this play is for them.

Characters

CASSIE

JAY

MRS REYNOLDS

KIERAN

MEL

ACT ONE

<div align="center">1.</div>

An interview room. A table.

On opposite sides of the table are JAY and MRS REYNOLDS.

JAY is in his late teens – he's a bit nervy, on edge, but with a ready smile.

MRS REYNOLDS is late fifties, early sixties, and harassed.

At the head of the table is CASSIE, a bright young professional woman in her twenties.

Some distance away, a WPC.

CASSIE takes up her notes.

CASSIE: Jay, you acknowledge that

 (Reading briskly.)

 Mrs Reynolds had put many hours' work
 Into her garden, all of which was lost
 As a result of your actions –

JAY: *(Interrupting.)* Yes I acknowledge that.

CASSIE: I'll just – read it all? And you can say yes or no at the end?

JAY: Oh okay.

 CASSIE continues to read – JAY greeting each point with a nod, or a 'yeah', but not breaking into her speech.

CASSIE: Mrs Reynolds felt insecure in her own home, never knowing
 When it might be attacked again.
 You acknowledge this was the result
 Of your actions.

And while having her house broken into
Was a traumatic experience for Mrs Reynolds,
It was the destruction of her garden
– an act of deliberate and purposeless vandalism –
Which caused Mrs Reynolds most distress.
You acknowledge that this was the result
Of your actions.

(She looks up from the paper.)

Do you agree to all that?

JAY: Yeah yeah yeah yeah, no problem.

CASSIE: Mrs Reynolds you've said

(Reading again.)

That as a result of meeting Jay
You feel less threatened and vulnerable –

MRS REYNOLDS: Not threatened at all by that little ruffian.

JAY: *(Jovial, not vicious.)* Ruffian? Where'd you get her, Antiques Roadshow?

CASSIE: *(Reading again.)*

Understanding that the incident
Was random, not specifically targeted,
Has left you feeling much less
Victimised.

(She looks up.)

Mrs Reynolds.

MRS REYNOLDS: Hello.

CASSIE: Understanding the incident was random and not specifically targeted at you has left you feeling much less victimised?

MRS REYNOLDS: Yes alright.

CASSIE: *(Back to the document.)*
 In order to rectify the situation, first
 Jay will formally apologise to Mrs Reynolds
 For the damage done. Second,
 Jay will undertake Community Payback –

MRS REYNOLDS: Sorry, Community Payback?

CASSIE: It's what they used to call Community Service, but
 then they decided – doing service to the community,
 sounds like it might have some sort of dignity about it, so
 they changed it to Community Punishment. But then if it's
 just a punishment what is the community getting out of it?
 So now they've gone for Community Payback.

MRS REYNOLDS: *(Beat.)* Right okay.

CASSIE: Jay will undertake Community Payback.
 He will make himself available
 At a time convenient to Mrs Reynolds
 And he will do such work around her garden
 As she specifies.

She looks up from the paper.

CASSIE: Okay so – do we all agree, what I read accurately
 represents the outcome of this meeting?

MRS REYNOLDS: A fairly sanitised version, yes.

CASSIE: Jay?

JAY: Totally yeah.

CASSIE: Great stuff. *(To the WPC.)* Debbie if you wouldn't
 mind? *(The WPC goes off.)* . Debbie will sort us out some tea
 and biscuits, which I think we've all earned. I'll pop next
 door, run off a couple of copies and then we can sign.

She leaves.

A moment.

And then JAY looks up and beams at MRS REYNOLDS. His demeanour has completely changed. He's swaggering, sprawling, full of attitude – and himself. He gets out a lighter and a pack of cigarettes.

MRS REYNOLDS: I doubt you're allowed to smoke in here.

Jay looks round.

JAY: I'm not seeing any signs.

Jay lights up.

JAY: Glad to hear you're feeling less victimised now. Cos of the *(Mimicking Cassie.)* 'random nature of the incident.'

MRS REYNOLDS: *(Of his cigarette.)* Each one of those is ten minutes off your life.

JAY: Pity it wasn't.

MRS REYNOLDS: Sorry?

JAY: I walk along your street every other day.
I see you, in your garden.
You always look so pleased with yourself.
It wasn't random. I did it on purpose.
And you should feel victimised. Because you are a victim.

CASSIE pops her head in.

CASSIE: Everything alright?

JAY: Just having a lovely little chat. About gardening.

CASSIE: Won't be a sec.

CASSIE is gone.

JAY: And if you repeat a word of what I just said, and I get put away – well that would not be too clever.

MRS REYNOLDS: You little / sod –

JAY: / You just, you be careful what you say now, cos I'm a lot of fun, I'm a fun kind of guy, but about this I am deadly serious. I got people. I got a strong support system. I know

you're fired up now and you want to have a go at me but – don't bother. Just suck it up. Sign the paper, say you are happy. Because if you don't –

CASSIE returns.

CASSIE: Can't smoke in here.

JAY: Sorry. You should put up some signs.

2.

The front garden of MRS REYNOLDS' house.

JAY is lounging around, finishing a packet of crisps. He flattens the packet, tips the crumbs directly into his mouth.

Then he scrunches the packet up, tosses it away.

MRS REYNOLDS emerges with a mug of tea.

JAY: What, no tea for the worker?

MRS REYNOLDS: Haven't seen you lift a finger.

JAY: Maybe you need your eyes fixing.

MRS REYNOLDS: If you think you can just loaf about, you've got another think coming.

JAY: Nah. I haven't.

MRS REYNOLDS: I'm not frightened of you…

JAY: Yeah you are. You're terrified.

MRS REYNOLDS: I know you think you're this ruffian –

JAY: I'm starting to really like that. 'Ruffian.' *(Echoing the Justin Timberlake song.)* I'm bringing ruffian back…

MRS REYNOLDS: If I make you some tea, then will you think about doing some work?

JAY: *(Beat.)* Milk and three sugars, please.

MRS REYNOLDS moves off.

JAY relaxes in the garden.

Sings a snatch of an incredibly offensive or insufferably irritating song (Something like the charming "I Wanna Fuck You" by Akon.) But he can sing a bleeped version, so he puts in a bleep where there should be an f-word.

Mrs Reynolds returns with a mug of tea.

MRS REYNOLDS: *(Forced cheer.)* There you go.

JAY takes a sip.

JAY: You trying to poison me?

MRS REYNOLDS: You said, milk and three sugars.

JAY: In my coffee. I never drink tea.

MRS REYNOLDS: You said to me, tea for the worker.

JAY: The eyes aren't the only thing on the way out. Your memory's going, love.

MRS REYNOLDS: I know what I heard.

JAY: When I was five a teabag burst and I swallowed a whole load of tealeaves and nearly choked to death. Since that day I've never touched tea in my life. I know I'm not your favourite boy in the whole wide world but – using my childhood traumas to get to me? That is cold, Mrs R.

He tips the tea away into the flower beds.

MRS REYNOLDS: You said you'd do some work if you got some tea, so now / let's see

JAY: / No no no, you asked me to think about doing some work.

MRS REYNOLDS: Oh for goodness' sake…

JAY: And I'm still thinking. I'm still thinking. I'm thinking – that there's something you forgot.

MRS REYNOLDS: What?

JAY: A tiny little word, that gets you what you want.

MRS REYNOLDS: I haven't got a clue what you're wittering on about.

JAY: 'Please'.

MRS REYNOLDS: Will you get to work on my garden as you promised you would. Please.

JAY: Wasn't so hard, was it? Where d'you want me to start?

MRS REYNOLDS: Just – do some weeding in those beds.

JAY: You're the boss.

JAY offers her his empty mug.

MRS REYNOLDS takes it, heads off.

JAY takes a look at the beds.

Puts on some gardening gloves.

Then walks up to a rose bush, grabs it by its lowest stems, just above the ground, and heaves away at it.

MRS REYNOLDS: What the bloody hell are you doing?

JAY: Oi oi oi! Language! Mind my delicate ears…

MRS REYNOLDS: That's a rose bush you're pulling up.

JAY: Is it?

MRS REYNOLDS: You'll've torn half the roots.

JAY: So weeding's not my thing.

MRS REYNOLDS: You'll've killed it.

JAY: Just doing what you told me.

MRS REYNOLDS: This is a joke to you, isn't it.

JAY considers, solemn. Then smiles.

JAY: Pretty much, yeah.

CASSIE enters.

CASSIE: Hello all, sorry I'm late. Targets meeting at HQ. There are targets, we're missing them. How're you two getting on?

JAY: Yeah, we're good.

CASSIE: Mrs Reynolds – happy? Happ-ier?

MRS REYNOLDS: He's hardly put it back like it was.

CASSIE: I think one of the things we established was that the damage Jay did was irreparable, in terms of your time, and your care for your garden; and so he's not going to be able to put that back, is he?

MRS REYNOLDS: Well no.

CASSIE: I mean – by definition.

JAY: Try to keep up, Mrs R.

CASSIE: What we're doing here today, it is practical I hope but it's a recognition that there's a debt to be paid and that Jay is willing to pay it. *(Beat.)* And do you feel he has?

MRS REYNOLDS: Sorry?

CASSIE: Do you feel Jay has recognised he owes you a debt?

A look between JAY and MRS REYNOLDS.

JAY: Take your time, Mrs R.

MRS REYNOLDS: Shall I put the kettle on?

CASSIE: *(Beat.)* Okay, yeah, do that. Have a little think about what I've said. And I'll have a chat to Jay.

MRS REYNOLDS goes inside.

CASSIE: So how's it been? Not strained yourself?

JAY: Sorry?

CASSIE: By working too hard.

JAY: Not really no.

CASSIE: No, thought not.

JAY: D'you know what –

(He's looking at Cassie.)

That's really interesting.

CASSIE: What is?

He turns away, picks a flower and gives it a sniff.

JAY: That's nice that is. Smells like air freshener.

CASSIE: What's really interesting, Jay?

JAY: She –

CASSIE: – Mrs Reynolds –

JAY: – well, obviously, yeah.

He stops, blinks.

CASSIE: What?

JAY: It's gone all up my nose.

He sneezes. CASSIE produces a packet of tissues. JAY takes one.

JAY: Cheers.

He blows his nose. Inspects the tissue. Then throws it away.

CASSIE: Jay!

JAY: What?

CASSIE gingerly picks up the scrunched up tissue and finds somewhere to put it.

JAY: Grandma Reynolds – round you she's like a mouse. Why is that?

CASSIE: We all relate to different people in different ways.

JAY: And some people we don't relate to at all.

MRS REYNOLDS brings out three teacups on a tray.

CASSIE: Mrs Reynolds, I'd like to chat to you about –

MRS REYNOLDS: Oh and biscuits, I meant to bring / biscuits

CASSIE: / I don't know if we'll have time for biscuits…

MRS REYNOLDS: They're just in the kitchen, won't take two seconds…

And MRS REYNOLDS goes in again.

CASSIE: Okay, I'll come with.

CASSIE follows her.

JAY gets up, fetches himself a cup of tea from the tray, then sits back down where he was.

He sips from the tea – then puts the cup down.

He gets up, walks back over to the tray, leans down, and dribbles spit into each of the two remaining cups.

Then goes back to where he was, sits back down, and resumes drinking his own tea. Grinning broadly now.

MRS REYNOLDS comes back out, carrying a plate of biscuits, CASSIE at her heel.

CASSIE: But there have been some positives from this morning?

MRS REYNOLDS: I suppose while he's here he's not causing mischief elsewhere.

(She puts down the biscuits.)

Help yourself.

JAY: I always do.

JAY takes two or three biscuits. One of them is a custard cream and he sets to work demolishing it by stages – nibbling off one half of the biscuit, then licking up the cream filling.

CASSIE: So do you think we can say –

JAY: How's your tea, Cass?

CASSIE: It's fine.

JAY: Makes a lovely cup of tea, doesn't she – our Mrs R.

CASSIE: Usually I'm a slave to the charms of the double shot latte but this really is hitting the spot, thanks.

MRS REYNOLDS: Just teabags, milk and water – it's hardly rocket science.

CASSIE: As I was saying, the point of this morning was for Jay to go some way towards rectifying the situation. How do we feel that's gone?

JAY: Brilliant. Couldn't've gone better.

CASSIE: And Mrs Reynolds?

MRS REYNOLDS: Well I –

She breaks off, lifts the cup to her mouth. JAY is watching carefully.

Then without taking a sip she continues speaking.

MRS REYNOLDS: I don't know if his heart's really in it.

JAY: Oh that's harsh, Mrs R.

CASSIE: And what makes you say that?

MRS REYNOLDS: Just a feeling.

CASSIE: And what gives you that feeling?

MRS REYNOLDS: The way he behaves.

CASSIE: What sort of behaviour, specifically, gives you the feeling Jay's heart isn't in it?

MRS REYNOLDS: And not just what he does. What he says as well.

CASSIE: What sorts of things does he say, Mrs Reynolds?

JAY: Yes, Mrs R, what have I said?

CASSIE: Specifically.

JAY: Be specific, Mrs R. Cause you're really upsetting me now. I'm really hurt.

MRS REYNOLDS: Well I don't know –

Again she lifts the cup to her mouth. Again JAY is on tenterhooks. And again she doesn't drink.

MRS REYNOLDS: His attitude.

CASSIE: Sometimes attitudes are difficult to judge. Say when people come from different backgrounds to us sometimes we can misinterpret the signals that are being given off. Do you think that's what might have happened today, possibly?

MRS REYNOLDS: I don't know.

JAY: You don't wanna misinterpret me, Mrs R.

CASSIE: Jay, shut up. *(To Mrs Reynolds).* I have a sense there are things you're not saying.

MRS REYNOLDS: Well I –

She lifts the cup to her mouth. JAY on tenterhooks again. MRS REYNOLDS stops. Looks into the cup. Looks up at JAY.

She throws the tea towards the root of the rosebush.

MRS REYNOLDS: It just seems – last Christmas kids came along and painted, you know graffitied –

CASSIE: Yes, I know.

MRS REYNOLDS: – the whole street. Every house along this side. And the council wrote to us. Said the "appearance of

our houses was detrimental to the area". Said we had to clear it up, or else.

CASSIE: Well that's – that's horrible.

MRS REYNOLDS: Cost me a hundred and fifty quid to get a man. And cars get smashed up or stolen – all the time. Sheila down the road's given up having one now. Doesn't bother. Too much hassle. D'you see? If you live in this street, you can't even have a car. Cause *(At JAY.)* they won't let you. If we were rich someone would stop it but – and now he waltzes along here for an hour – and he's just let off?

CASSIE: I understand your frustration, and I don't know what went wrong with the graffiti incident, that just sounds like a horrible, horrible mistake somewhere – but that was nothing to do with Jay. And we're here to deal with what Jay did to your garden. So – do you feel Jay hasn't done enough? He could come back another day and do more. But would you want him to come back?

JAY: I could come back, Mrs R. With some friends maybe. Do a proper job.

MRS REYNOLDS: No I don't want that.

JAY: No I thought not.

CASSIE: So we'll say – you're content?

MRS REYNOLDS doesn't answer.

CASSIE: Everything I've learned, everything I've seen in this job tells me, if Jay goes to prison, it will not help. He'll come out worse.

At this MRS REYNOLDS seems to soften a little. But then –

JAY: Imagine that. Imagine me – but worse.

CASSIE: And it's a real pity your flower displays will be a bit depleted this summer but – there's always next year?

MRS REYNOLDS: *(Beat.)* Yes of course.

MRS REYNOLDS looks out over what remains of her garden − it's just a tiny moment.

MRS REYNOLDS: You're right. He's turned up, he's done his best. I'm satisfied.

CASSIE: I'm really pleased to hear that.

JAY: I am too, Mrs R. Pleased and relieved. For the both of us.

CASSIE: Some people find they want to shake hands at this point.

MRS REYNOLDS: Do they.

CASSIE: You might find it helps you reach a point of closure −

JAY: I'll shake. No problem.

JAY extends his hand.

CASSIE: The courts take it as quite a big symbolic thing, if the victim and offender shake hands.

MRS REYNOLDS: Say we did then.

CASSIE: You're perfectly free not to shake hands with Jay. If that's how you want the record to stand.

JAY: Is that, how you want the record to stand, Mrs R?

MRS REYNOLDS steps towards JAY, takes his hand. They shake.

JAY: Nice we can part as friends.

JAY holds the handshake for longer than MRS REYNOLDS wants to. She slightly snatches her hand away from him.

MRS REYNOLDS: I'll get your coat.

MRS REYNOLDS leaves, quickly.

CASSIE is watching JAY.

JAY: What?

CASSIE: Just.

JAY: Just, what?

CASSIE: Don't make me regret… you know.

JAY: Regret what?

CASSIE: She could've gone either way.

MRS REYNOLDS returns with JAY's jacket.

MRS REYNOLDS: Here you go.

CASSIE: What I can do, Mrs Reynolds, is give you the number of Victim Support, they might be able to offer you counselling in relation to the various offences you were talking about…

MRS REYNOLDS holds the jacket out so JAY can put it on.

JAY: Very kind.

JAY goes to put the jacket on. As he does so, something falls out.

CASSIE: Think you dropped something there.

CASSIE bends and picks up a pearl necklace. She holds it for a moment.

MRS REYNOLDS: My pearls. How did they get in your coat?

JAY: Not a clue.

MRS REYNOLDS: You tell me to give him a chance, so I give him a chance, I let him into my home – and the little thug steals from me!

CASSIE: I don't know what to say…

JAY: *(Re Cassie's speechlessness.)* Every cloud, eh.

MRS REYNOLDS: This was a present, from my husband.

JAY: I don't know how it got there, alright?

MRS REYNOLDS: Our thirtieth anniversary…

JAY: How stupid do you think I am?
Anything goes missing while I'm here
Then I'm in the frame.

MRS REYNOLDS: Sounds like you've given it some thought...

JAY: It's obvious!

CASSIE: Were you wearing it today? Could it've fallen from your neck?

MRS REYNOLDS: *(To Cassie.)* He's got you believing him already!

CASSIE: I just want to make sure of every possibility.

MRS REYNOLDS: I can't remember the last time I wore it. It's worth money. He's been into my bedroom, gone through my things.

JAY: I haven't even been in your house!

MRS REYNOLDS: You have, you went to the toilet.

JAY: Okay, yeah, but apart from that –

MRS REYNOLDS: I remember thinking you were taking your time.

JAY: What was I supposed to do, piss in a bottle?

MRS REYNOLDS: You see he lies, he lies at every step.

JAY: I forgot about that, alright?

MRS REYNOLDS: You look me in the eye and you swear you didn't steal from me.

JAY: I swear –

He hesitates, struggles, cannot help but break into a smile.

JAY: I'm sorry, I'm sorry –

MRS REYNOLDS: He can't do it. He can't look me in the eye.

JAY: It's just you're being so deadly serious and – over nothing.

CASSIE: Jay, this is not nothing. This is a really serious abuse
of trust.

JAY: Let me guess, you're not angry
You're just really really disappointed.

CASSIE: Actually it's exactly the opposite.
I'm bloody furious.

CASSIE gets out her phone.

JAY: What are you doing?

CASSIE: I'm calling the police.

JAY: You're turning me in?

CASSIE shrugs.

JAY: Is that it? You're just –
– shrugging at me?

CASSIE: Should've thought of that before.

JAY: This is a set-up!

CASSIE: *(On phone.)* Yes hello, I'd like to report a crime.

(Beat.)

No it's not an emergency.

(Beat.)

Yes I'll hold.

MRS REYNOLDS: What will happen, when the police come?

CASSIE: I don't think his application for bail will be looked on
too kindly this time.

MRS REYNOLDS: He'll go to jail?

CASSIE: He'll be on remand.

MRS REYNOLDS: But locked up?

CASSIE: Oh yes.

JAY: *(To Mrs Reynolds.)* You are loving this, aren't you?

MRS REYNOLDS: Loving that you came into my house and stole from me? No, I don't think so.

CASSIE: *(On phone.)* Yes I'm still holding.

JAY: I didn't steal from you.

MRS REYNOLDS: Only because you got found out. *(To Cassie.)* Even now, and he won't admit what he's done…

JAY: I hate to keep coming back to this boring, you know, FACT, but I didn't do it!

CASSIE: *(On the phone.)* Yes hello? Hi. Yes I'd like to report a – yes I'll hold.

MRS REYNOLDS: If that's your attitude, then locked up is the best place for you.

JAY: No, it's not, it's the worst place, I swear to God.

MRS REYNOLDS: Not so full of yourself now, are you?

JAY: Do you want me to lie, and say I did it?

MRS REYNOLDS: No.

JAY: What then?

MRS REYNOLDS: I want you to tell the truth. And say you did it.

CASSIE: *(To Mrs Reynolds.)* They're sending a car now.

JAY: Alright! I admit it!

MRS REYNOLDS reaches out to CASSIE.

CASSIE: *(On phone.)* Um – would you mind holding for a second?

CASSIE lowers the phone, hand over its microphone.

MRS REYNOLDS: Tell us what you did.

JAY: I snuck into your bedroom, I went through your
jewellery, saw the necklace, thought, right, I'll have that.

MRS REYNOLDS: Then what?

JAY: Then I heard you coming. I slipped it in my jacket pocket.

MRS REYNOLDS: That's the truth?

JAY: *(Beat.)* And nothing but.

MRS REYNOLDS: Cassie, maybe we can sort this out between
ourselves.

CASSIE: *(On phone.)* Hi. Actually – it's fine. False alarm. Sorry
for wasting your time.

She ends the call.

CASSIE: What exactly are you saying, Mrs Reynolds?

MRS REYNOLDS: The second he thinks he's really going to jail,
He's terrified.
We're making progress.

3.

A little way from MRS REYNOLDS' house, in a small paved area created to stop joyriders using the street as a ratrun.

There's a fairly big raised bed, into which a young tree was once planted. All that remains of it is a metre or so of thin trunk sticking up from the bed.

To one side of the bed, a bench. Scrawled across it in white marker is the legend 'The Adeline Street Sherry Bench.'

Behind the bench, a brick wall. Long-rusted barbed wire loops across its top, carrier bags caught on the barbs. Lots of graffiti on the wall. Prominent amongst it – certainly visible to the audience – is the legend 'Natille is a slag and a prostitute.'

MRS REYNOLDS arrives, carrying a couple of jute bags in one hand and a watering can in the other.

JAY follows her.

MRS REYNOLDS stops, puts down the bags and watering can. Looks round her – and then expectantly, to JAY.

JAY: What?

MRS REYNOLDS: Look at this.

JAY: What about it?

MRS REYNOLDS: It's horrible – isn't it?

JAY: Dunno.

MRS REYNOLDS: Oh it is horrible, Jay. You're just being your usual kind self in not saying so. What happened was, kids were stealing cars and tearing up and down the street, so they paved this bit off. Put in a bench. This little planter. Stuck a tree in it. *(Beat.)* The tree lasted three days. Look you can see – they snapped it off at the trunk. Must have taken quite an effort. Council haven't bothered to replace it – why would they?

– and the bench has now been christened *(She reads.)* 'The Adeline Street Sherry Bench'. Which is lovely.

JAY: *(Beat.)* And?

MRS REYNOLDS: And I am sick of looking at this horribleness. We are going to make it beautiful. Or, I tell the police you tried to steal from me and tonight you'll be sharing a landing with some very rough men indeed.

JAY: This is so not fair.

MRS REYNOLDS: It's so not – what?

JAY: Forget it.

MRS REYNOLDS: No, go on – say it again. I love it. I love hearing you complain about things being 'not fair.'

JAY stays silent.

MRS REYNOLDS: No? Let's get to work, then. First we need to clean up a bit – well, I say we…

From her bag she produces a folded up bin bag, and offers it to JAY. He takes it, goes over to the planter.

MRS REYNOLDS: There's broken glass and general nastiness in there *(She means the planter)*. You should probably have some gloves.

JAY walks back to MRS REYNOLDS. She hesitates, enjoying the moment – then gets from her bag a pair of pink rubber washing up gloves. She holds them out to JAY.

JAY: Very funny, Mrs R.

MRS REYNOLDS: Now you can start to wonder – did I happen to have pink rubber gloves in a man's size lying about the house, or did I go out to buy some, just to make you wear them.
What's your verdict?

JAY looks at her.

MRS REYNOLDS: Little bit of the tough guy stare – but you're learning to keep your trap shut, which is a vast improvement. So snap on the marigolds, and step to it.

JAY does as he is told. MRS REYNOLDS takes a small sheet of sandpaper from her bag. Sits on the bench, and begins to sand away at some of the graffiti. JAY snaps on the gloves, starts picking up rubbish from the planter.

After a very short while – only thirty or forty seconds – MRS REYNOLDS has to stop sanding. She stretches her fingers to loosen them up, and tries again. It's no good. She switches hands.

JAY: So we gonna be long?

MRS REYNOLDS: We'll be as long as it takes.

JAY: I've gotta sign on.

MRS REYNOLDS: I'm sorry?

JAY: Sign on? At the dole?

MRS REYNOLDS: Oh of course. Jay the gangster. Queueing up at the social, filling out his forms.

JAY: So what?

MRS REYNOLDS: You think you're some kind of outlaw. You couldn't survive five minutes without the law.

JAY: S'alright. I'll tell 'em I was late cos the old lady who's blackmailing me wouldn't let me come in on time.

MRS REYNOLDS: Mmm. You still said 'old lady' though. Not 'old cow'. Or 'old bitch'. Which is obviously what you were thinking.

JAY: Can't stop what goes on in my head, Mrs R.

MRS REYNOLDS: I couldn't care less what nastiness goes on in your vile little head. I just don't want it to impinge on me, ever. And it looks like I'm getting my way.

JAY gets back to picking up rubbish from the planter. MRS REYNOLDS sits, kneading her knuckles.

JAY: Alright I'm finished.

MRS REYNOLDS: Wonderful.

JAY: So can I go?

MRS REYNOLDS: Is this place beautiful? No it is not. Can you go? What d'you think?

MRS REYNOLDS picks up one of her bags, and walks over to the planter.

MRS REYNOLDS: I told Sheila down the road I was going to tidy up this bed, and she said she had a few spares. We have two rudbeckia, three lobelia, and – I don't actually know what those are, but beggars can't be choosers.

She offers him a pot.

JAY: Where do I stick it? *(Quieter.)* Apart from up your arse…

MRS REYNOLDS: What was that?

JAY: Nothing, Mrs R.

MRS REYNOLDS takes the pot back from him.

MRS REYNOLDS: You don't stick anything.
First you observe.
We water the plant, thoroughly.
We dig a little hole, removing non-organic debris, and stones.
We loosen the earth at the bottom of the hole
So it's easy for the roots to spread.
We get the loose earth nice and wet.
We lift the plant from its pot – it pops out,
Thanks to having been watered so thoroughly,
Just moments before.
We loosen the rootball.
We place the plant in the hole.
We push the earth we dug out, back in.

> Then we tamp the earth down,
> Gently but firmly around the plant.

JAY: Gently – but firmly at the same time?

MRS REYNOLDS: Yes, that's right.

JAY: *(Beat.)* Whatever.

MRS REYNOLDS: As one might be gentle but firm with a lover, for example.

JAY: Oh my gosh, I do not need to hear this...

MRS REYNOLDS: Do you think you can manage that?

JAY: What-ever.

JAY and MRS REYNOLDS both get to work planting, MRS REYNOLDS keeping an eye on JAY's progress.

MRS REYNOLDS: Don't forget to loosen the earth at the bottom of the hole.

JAY: Yeah, I know...

A moment of planting activity.

MRS REYNOLDS: Very nice woman, Sheila.

JAY looks at her.

MRS REYNOLDS: Who gave us the plants?

JAY: Oh right.

MRS REYNOLDS: Mmm. A lesbian, I believe. *(Beat.)* A lot of it about these days – lesbianism.

JAY: Hey, how can you tell a lesbian bar?

MRS REYNOLDS: I don't want to know.

JAY: Not even the pool table's got balls.

MRS REYNOLDS: Sometimes I wonder why that is. Why so many of the young women are lesbians these days. And

then I look at a young man like you, and I think – well it's no wonder at all, is it?

JAY doesn't rise to it. He just picks up another plant.

MRS REYNOLDS inspects his work.

MRS REYNOLDS: That last one's not bad, you know. See it's standing up nice and straight. Done a good job there.

JAY: Yeah, right.

MRS REYNOLDS: I'm serious, look at the first one you did – and then look at that last one. Can you can see the difference?

JAY: No.

MRS REYNOLDS: You've learned how to plant something.

JAY: Couldn't give a toss.

MRS REYNOLDS: *(Beat.)* Fine. Off you go, then.

MRS REYNOLDS turns away from him, begins packing up tools and plant pots.

JAY: On the bus, I'm gonna make spitballs. Like bits of paper,
That you chew up with spit?

MRS REYNOLDS: Yes, I know.

JAY: I'm gonna pick someone.
An old bloke. Or some fat woman.
Some prick with big glasses and a haircut.
I'm gonna sit behind them.
I'm gonna chuck spitballs
At the back of their head.
And one they'll think it's just nothing.
Then the second, the third,
They'll know there's something going on.
But still they'll sit there.
They'll just take it.
Because they always do.

So I'll keep chucking them.
Till finally they've got to turn round.
And I'll throw a lovely ball of my flob
Right in the face of the fat bint. Or the old bloke.
Or the poor mum with all her kiddies.
And I will smile.
And that smile – will be for you, Mrs R.
And I'm gonna do that every day.
I'm gonna pick on someone,
Terrorise them,
Every day you make me come here.

MRS REYNOLDS: I hope they smack you in the mouth.

JAY: They do, I'll get the law on them.

MRS REYNOLDS: Oh yes, the law – the hoodie's best friend.

JAY: You're a player, you play the system.
Course you could stop it, Mrs R.
You could save all those innocent people
From being terrorised,
If you just let me be on my way.

MRS REYNOLDS: Course if you just sat on the bus, minded
your business,
No-one would even notice you existed.
But you sprawl across the seats,
Music blaring out your phone,
Swearing and cursing and being foul –
Everyone sees you then. Everyone notices.
And that's what you want.
You want people like me, to even notice you exist.
Well I noticed. We all did.
We were just ignoring you, hoping you would go away.
But I know now you won't.
And I can't ignore you any more.
Cause you, have got to be stopped.

4.

Same as before: the planter, the wall covered in graffiti. But the flowers JAY planted have been ripped up. Their remains are scattered across the stage.

JAY arrives first, carrying a watering can. He takes in the destruction. And is delighted.

JAY: Oh, yes...
That is fantastic work.

MRS REYNOLDS follows, carrying bags and a watering can.

JAY: Morning, Mrs R. And how are you, this fine day?

Mrs Reynolds looks about her.

JAY: Now look, I am dying to get busy with the watering can but − what is there to water?

MRS REYNOLDS: Yes, I see your problem.

JAY: So what, I'll be off then, shall I? If there's nothing for me to do here.

MRS REYNOLDS: Jay: d'you think this is a disappointment for me? A shock?

JAY: You made me plant the flowers, I'm guessing you wanted them to stay planted...

MRS REYNOLDS: Oh no, I knew some little thugs would tear them up.

JAY: What was the point making me doing it then?

MRS REYNOLDS: How does it feel, looking around?

JAY: How does what now?

MRS REYNOLDS: How does it feel, seeing your work ruined.

JAY: Couldn't give a toss.

MRS REYNOLDS: All your effort.

JAY: Yeah I didn't put that much effort in though.

MRS REYNOLDS: It doesn't bother you, that everything you've done has been spoiled?

JAY: I never wanted to do it – why'm I gonna get worked up about it?

MRS REYNOLDS: Fair point.

JAY: So like – can I go?

MRS REYNOLDS: 'Fraid not, no.

She gets from her bag a sunflower – a young plant, with no flowers as yet.

JAY: Oh, what is this?

MRS REYNOLDS: This is a Russian Giant.

He looks at her – what the hell is that?

MRS REYNOLDS: A sunflower. Spare from my garden.

She offers the plant to him.

MRS REYNOLDS: Come on. You know the drill.

JAY: But what's the point?

MRS REYNOLDS: The point is that a bright and beautiful sunflower will cheer up everyone who passes.

JAY: Except it's gonna get pulled up. Just like the others. And you know this. You're just doing it to torment me.

MRS REYNOLDS: Not to torment you, no.

JAY: And what then? When we come back tomorrow and this one is gone?

MRS REYNOLDS: Then – we plant something else. *(Meaning the sunflower.)* Put it close to the trunk, and then we can use that to give it support.

JAY: Yesterday, you had loads of plants. Today, we're down
 to one. That whole thing, just one flower in it? You're
 running out. Tonight they'll tear your Russian Giant to bits,
 tomorrow – you'll have nothing. They're gonna beat you,
 Mrs R.

MRS REYNOLDS: That's right, Jay. We're trying to make things
 better, and the thugs and vandals are beating us.

JAY: It's not me that's trying. It's you. I don't give a toss.

MRS REYNOLDS: I know it's hard for you.
 You're young, and young people
 Don't believe in change,
 Having not lived long enough
 But believe you me,
 You will have people you care about,
 People you love, and
 The thought of anything happening to them –
JAY: The ones I love, I protect with my life.

MRS REYNOLDS: You can't be everywhere.
 You can't be there, all the time.

JAY: I'll do my best.

MRS REYNOLDS: You'll fail.

JAY: I won't.

MRS REYNOLDS: Yes you will. We all do.

JAY: Not me.

MRS REYNOLDS: All you can hope for is
 That the world is kind to the ones you love.

JAY: Not much chance of that.

MRS REYNOLDS: And by being such a selfish, nasty, ignorant
 toe-rag
 You make the world a little bit less kind every day.
 The way you act will come back, not just on you
 But on the ones you care about.

51

JAY: Couldn't give a toss.

MRS REYNOLDS: You will.

JAY: But I don't

MRS REYNOLDS: But you will.

JAY: So what?
I don't care
What I will care about.
I only care
What I care about now.
And what I care about now –

MRS REYNOLDS: – is your own sweet self, and sod all else.

JAY: Mrs R – you're starting to get me. I love it. What a
beautiful hands-across-the ocean moment.

MRS REYNOLDS: Alright –

JAY: *(Cheery, sensing victory.)* You're giving up? I knew you
would…

MRS REYNOLDS: *(The sunflower.)* Plant that. I'll be back.

JAY: Whatever you say, Mrs R…

JAY gets to work planting the sunflower.

MRS REYNOLDS heads off.

Once she's gone, JAY sits on the bench, stretches.

*After a bit he hears MRS REYNOLDS returning. He jumps up and
gets back to the planter.*

*MRS REYNOLDS enters, carrying a big paintbrush and a tin of white
masonry paint.*

JAY: Nearly finished.

She puts down the paint, goes over to the wall.

MRS REYNOLDS: 'Natille is a slag, and a prostitute.' Natalie spelt incorrectly – but prostitute spelled right.

JAY: Can spell your name how you like.

MRS REYNOLDS: You can – doesn't make it right. Just means you've chosen to have your name spelled wrong, for the whole of your life.

JAY: Says you.

MRS REYNOLDS: Yes I do.

MRS REYNOLDS puts the paint and brush at his feet.

JAY: You want me to paint over it?

MRS REYNOLDS: You're going to paint the whole wall.

JAY: What for?

MRS REYNOLDS: I don't want to look at – any of this, ever again.

JAY: But there'll just be more graffiti up tomorrow.

MRS REYNOLDS: Will there?

JAY: Well, duuuh.

MRS REYNOLDS: Well, duuuh, then you'll come back tomorrow, and you'll paint over it a second time.

JAY: And there'll be more again the day after.

MRS REYNOLDS: And you'll come back that day. And you'll come back the day after that. The boy that runs the shop on Carlisle Street, I knew his dad, he'll chuck cans of white paint my way as long as I like.

JAY: What's the point painting over graffiti when there's gonna be more up tomorrow?

MRS REYNOLDS: Because every day for seven years I have been reminded that 'Natille is a slag and a prostitute', and I have had enough.

She gathers herself.

MRS REYNOLDS: I'll finish that *(Planting the sunflower).* You get started on that wall.

JAY: Jesus, what did your last slave die of?

MRS REYNOLDS: Exhaustion: why d'you ask?

JAY fiddles feebly with the paint tin.

JAY: Can't get the lid off.

MRS REYNOLDS: Bring it here.

JAY does as he's told. MRS REYNOLDS tries to prise the lid off with her fingertips. Fails. She looks round the planter.

MRS REYNOLDS: Pass me that stone.

JAY moves.

MRS REYNOLDS: No, the flat one.

JAY passes MRS REYNOLDS a stone. She slots the stone under the rim of the lid and tries again. Still no good.

MRS REYNOLDS shakes her hands.

MRS REYNOLDS: Well – you're not going till the job's done.

She hands the tin back to him, returns her attention to the sunflower.

JAY stares daggers at her.

Then lifts the lid off the paint tin, easily and without any fuss.

He begins to paint the wall – his back to MRS REYNOLDS.

After a moment MRS REYNOLDS stops what she's doing, watches him.

MRS REYNOLDS: My husband would've knocked you into the middle of next week for even looking at me the way you did just then.

JAY: *(Not really turning to look at her.)* What's he gonna do, bash me with his zimmer frame?

MRS REYNOLDS: Mr Reynolds has passed on.

JAY: *(And now he looks at her.)* Passed on? You mean he's wormfood?

MRS REYNOLDS: Worked every day from sixteen to sixty-five.
Saw to it his kids went for nothing.
Hundreds turned out for his funeral.
He did more good in a morning than you'll do your whole life.

JAY: *(Beat.)* Who even gives a toss?

MRS REYNOLDS controls herself – but Jay knows he's found a weak spot.

JAY: Where are your kids then? Don't notice them coming around to keep you safe from *(Enjoying the word.)* ruffians like me.

MRS REYNOLDS: Ben lives in Glasgow and Rhiannon has a family in Australia.

JAY: Bloody hell, Mrs R. Good mum, were you?

MRS REYNOLDS: I'm very proud my children are independent enough they can go anywhere they want and make new lives for themselves.

JAY: No you're not. Course you bloody aren't.

MRS REYNOLDS: I speak to my grandchildren over the internet two or three times a week, more than when they lived here.

JAY: Maybe it wasn't you. Maybe it was Mr R. Did your little Rhiannon ever get a bit nervous, around him? Say after she started to 'blossom'? I mean I used to run away, but only down the end of the street. Australia though. You can't run much further than that, can you?

He turns away, returns to painting.

MRS REYNOLDS: You useless little piece of shit.

JAY: *(Turning back to her.)* Easy Mrs R…

But there is such fury in her that his nerve deserts him.

There's a moment when he's too frightened to speak, and she's too angry.

JAY: Look. You know, this is pointless. You know that.

MRS REYNOLDS: You're still going to bloody do it. For however long I like.

JAY: Right you sweep up the pavement in front of your house. Why'd you bother?

MRS REYNOLDS: It won't sweep itself.

JAY: It's the pavement. It's not yours.

MRS REYNOLDS: It's in front of my house.

JAY: So?

MRS REYNOLDS: If the pavement in front of my house is filthy – it upsets me. When people drop crisp packets, and cigarette packets, and let their dogs defecate right in front of my house, I hate it.

JAY: When kids do graffiti, they're doing the same as you, when you sweep the pavement.

MRS REYNOLDS: Sorry?

JAY: The pavement.
It's not yours,
But it's part of your life
So you try and make it yours.
You sweep it up.
You keep it clean.
If you're a kid, you've got nothing.
Not a house, not a garden.

You've got the street you walk along.
The bit of wall by the shop.
The bus stop.
Nothing really.
But what you've got
You try and make it your own.
You sign your name. You tag,
Everywhere you go
And soon the city
Is your home. It shouts your name
As you pass.

(Beat.)

It's the same:
What you do,
What they do.

MRS REYNOLDS: It is a little the same, I suppose.

JAY: What, are you listening, finally?

MRS REYNOLDS: What I do – sweeping up broken glass, hosing down dog crap – makes the world better, for everyone. Foul language scrawled everywhere you look, makes things worse. So they're not the same at all.

JAY: It's not foul language.

MRS REYNOLDS: Clearly it is.

JAY: That's just how we talk.

MRS REYNOLDS: I'm sick of you how you talk. We all are.

JAY: I can't win, can I…

JAY gets back to painting.

MRS REYNOLDS: But d'you know what you did there?

JAY: *(Infinitely weary.)* No…

MRS REYNOLDS: It wasn't threats, it wasn't excuses, it wasn't lies. You tried to reason with me. Like a civilised young man.

JAY: Lot of good it did me.

MRS REYNOLDS: You're right: progress should be rewarded.

JAY: Like how?

MRS REYNOLDS: You say there's no way this wall will be graffiti-free in the morning.

JAY: It's like a whatchamacall, a blank –

MRS REYNOLDS: Canvas?

JAY: Yes! You're asking people to tag it.

MRS REYNOLDS: Prove yourself wrong. Keep this wall clean for one night, and we'll call it quits.

JAY: What, I stay here? All night?

MRS REYNOLDS: It's warm. It's not going to rain. And don't tell me you've never stayed up all night before.

JAY: And then I can go? You'll sign my report, and you'll never hassle me again?

MRS REYNOLDS: Oh I love it. In your head, I'm 'hassling' you...

JAY: But that's the deal?

MRS REYNOLDS: If I can walk down my own street, just one bright morning, and not be faced with filth and foul language – yes. If you do that for me, we're even.

JAY: Shake on it.

JAY offers his hand.

MRS REYNOLDS takes it.

They shake.

5.

Later in the day.

JAY is sitting on the bench, listening to music from his mobile.

Light begins to fade.

JAY gets bored of music. Begins playing a game on his phone.

It's getting darker.

JAY's battery runs out. He puts the phone away.

Tugs his jacket tighter around himself.

Darker still.

JAY gets out a cigarette. Smokes it.

Settles.

Starts to doze.

KIERAN: Mate.

 JAY comes awake.

KIERAN: 'Sup?

JAY: Nothing.

 KIERAN approaches; they shake.

KIERAN: Coming into town?

JAY: In a bit.

KIERAN: What you doing?

JAY: Not much.

KIERAN: Not much?

JAY: *(Beat.)* Sitting.

KIERAN: So… you coming then?

JAY: Yeah, no I'm just gonna hang here a bit.

KIERAN: Hang here?

JAY: Yup.

KIERAN looks around, trying to find the attraction of 'here'.

KIERAN: Why?

JAY: What the fuck d'you care?

KIERAN: Mate, I don't. I'm just –

Stung by JAY's reprimand, KIERAN has pulled back a bit. Out of the corner of his eye he notices – the wall.

KIERAN: – oh my gosh.

He gets up.

KIERAN: Have you seen this?

JAY: What?

KIERAN: This wall.

JAY: *(Meaning: what are you getting excited about?.)* It's a wall.

KIERAN: It is a pure, pristine, beautiful, white wall.

JAY: So've you seen Damian? We was going down Apollo's and he jibbed out last minute.

Kieran pulls out a marker pen.

KIERAN: It is my pristine, white wall.

He pulls off the top of the marker. Gives it a little sniff for luck.

JAY: Oi oi Kieran.

KIERAN: What mate?

JAY gets up.

JAY: Alright, come on, let's head into town then.

KIERAN is considering the wall – where he should start, and with what.

KIERAN: In a second mate.

He chooses his spot. He's just about to write on the wall –

– and JAY grabs his hand.

JAY: You can't.

KIERAN pulls free.

KIERAN: You what?

JAY: You can't touch it.

KIERAN: Yeah, I can...

JAY: You do, I will fucking end you mate.

KIERAN looks at him. Smiles.

KIERAN: Come again?

JAY: You heard me.

KIERAN: Is this – are there cameras? Are we on TV?

JAY: It's not a joke.

KIERAN: What then?

JAY: *(Beat.)* Can't say.

KIERAN: What, is it secret? Is it top secret? Are you like, a spy, and keeping this wall clean, is your secret mission?

JAY: Don't take the piss, mate.

KIERAN: Don't you take the piss, then.

Beat.

KIERAN: Is it your community service?

JAY says nothing.

KIERAN: Is it! What – they got you to paint the wall – and now they're making you stand guard?

JAY: Something like that...

KIERAN: They can't do that mate! You've got rights! They can't have you standing out here all night. Anything could happen.

JAY: Don't I know it.

KIERAN: That's got to be dodgy, though. You should tell your solicitor. Have you told your solicitor?

JAY: No.

KIERAN: You should mate.

JAY: Yeah I will.

KIERAN: I could punch you and then you can sue. Say you were attacked.

JAY: Can't afford to sue anyone, can I.

KIERAN: No win no fee, mate. Your legal costs will be paid by the insurers of the third party, innit.

JAY: You are not gonna punch me, and that is the end of it.

KIERAN: Alright, alright...

JAY goes back to the bench.

KIERAN: So what, you gotta keep anyone from graffiti-ing this wall?

KIERAN looks at the wall. Still has the marker in his hand.

JAY: 'Sright.

KIERAN: Gotta keep it perfect?

He's reaching out towards the wall with the pen.

JAY: Kieran.

JAY not looking at him. He doesn't need to.

KIERAN: What?

JAY: Come here, sit down.

KIERAN does as he is told.

KIERAN: So… you're gonna stay here all night?

JAY: Yup.

KIERAN: *(Beat.)* No you ain't.

JAY looks at him.

KIERAN: Come on mate, as if.

JAY: Laugh it up.

KIERAN: You know what you're like though.

JAY: What'm I like, mate. You tell me.

KIERAN: Don't be a little bitch…

JAY looks at him: looks away.

KIERAN: By the way, saw your sister earlier. She said, what was it…

JAY: She said, Kee, do you have any idea how annoying you are?

KIERAN: Oh yeah, she said 'Give it to me Kieran, give it to me hard, like the slut I am.'

JAY: When'd you see my sister?

KIERAN: When did I – shag your sister? Last night. Tried to call you so you could listen in.

JAY: Well I was busy, shagging your mum.

KIERAN: I was shagging your nan.

JAY: I was shagging yours.

KIERAN: My nan's dead.

JAY: I thought she was a bit quiet. And smelly.

KIERAN: I loved my nan, mate.

JAY: And I did. Three times a week, twice on Fridays.

KIERAN: *(Beat.)* You're really just sitting here, all night?

JAY: That's what I said.

KIERAN: I'm going by KFC, why don't you come with?

JAY: Cause I'm staying here!

KIERAN: Gonna need a feed, maintain your energy levels.

JAY: I'm as energetic as I need to be, mate.

KIERAN: I'd bring you some, but I'm off to Boycey's.

JAY: I'll be alright, mate.

KIERAN: Get a coffee, few Cokes, keep you going. Be gone half an hour tops.

JAY: Nah, I'm good.

KIERAN: *(Beat.)* Boycey'll have a bit of speed tucked away somewhere. If you're staying up all night.

JAY looks at him – doesn't answer.

KIERAN is triumphant.

KIERAN: On your feet, soldier.

KIERAN springs up.

JAY: Straight to Boycey's then.

KIERAN: KFC first.

JAY: KFC, Boycey's for the speed, then I'm coming right back.

KIERAN smiles.

KIERAN: Course you are, mate.

6.

The next morning.

The sunflower is ripped up.

On the wall has been scrawled 'Stacey lyks cock'.

MRS REYNOLDS is sitting on the bench, waiting.

JAY arrives in the same clothes he was wearing last night. He's haggard and bleary.

MRS REYNOLDS: You're here. Wonderful. Now, this is worth taking a look at...

She gets up, goes over to the wall.

MRS REYNOLDS: Because there are people who say, does spelling really matter? So long as you can get your message across, who cares if words are spelled how a stuffy old dictionary says they should be. *(The graffito.)* But see – someone is trying to tell us something about Stacey. Is it that she likes cock? Or that she licks it? I can't be sure. And why not? Because of poor spelling.

JAY: See – that, that is bad luck.

MRS REYNOLDS: Is it?

JAY: That can only've happened like, five seconds ago, cos I was here the whole time.

MRS REYNOLDS touches the graffiti.

MRS REYNOLDS: Ink's not wet.

JAY: Half an hour ago then, tops. I was here all night, popped off to get a coffee – just my luck, that's when some little vandal wanders past with his marker pen...

MRS REYNOLDS: Where is your coffee, then?

JAY: Drank it.

MRS REYNOLDS: I looked out half eleven last night, you were nowhere to be seen.

JAY: Half-eleven? I was seat of pants to seat of bench. Did you have your specs on?

MRS REYNOLDS: I came out half twelve, you were gone.

JAY: 'Bout half-twelve I might've stretched my legs, walked up and down the street, but...

MRS REYNOLDS: I knew you couldn't do it.

JAY: *(Beat.)* Did you?

MRS REYNOLDS: One hundred per cent certainty.

JAY: Did you think I was gonna sit up all night? Who, in the world, would do that?

MRS REYNOLDS: Have you ever seen – the sea, Jay?

The tiniest hesitation before he answers.

JAY: Course.

MRS REYNOLDS: You know nothing about the world, but hark at you telling us all how it is...

JAY: I know more than you, sat in your nice little house. The real world – is a jungle.

MRS REYNOLDS: Oh that's brilliant. It's a jungle. And what are you, Jay? A lion? A tiger? No – Jay the Jaguar, stalking the streets of the urban jungle. That's marvellous.

JAY: Is it.

MRS REYNOLDS: Oh sorry – a jaguar is a big cat, bit like a leopard or a panther. Just in case you didn't know.

JAY: *(Controlled.)* You know it really pisses me off when you laugh at me.

MRS REYNOLDS: There he goes – Jay the Jaguar, stalking down to the dole office, to sign on the line and get his pocket money…

JAY: A player plays / the –

MRS REYNOLDS: / the system, I know… I've heard it before. I've heard all your excuses, and I am sick of them.

She looks at him.

MRS REYNOLDS: When my kids were little, a sliver of mercury above ninety-eight and I'd sit up with them all night.

JAY: *(Beat.)* I don't know what that means.

MRS REYNOLDS: If they had a hint of a temperature.
We measured it in Farenheit.
I would watch them.
I would count every breath,
From the moment they laid down their head
Till light filled the room
And their eyes opened.

(Beat.)

I bet no-one ever did that for you.

JAY shakes his head.

MRS REYNOLDS: No. And I'm not surprised.

JAY: What?

MRS REYNOLDS: My children were angels. You – I dread to think.

JAY: You don't wanna hear what it was like when I was little.

MRS REYNOLDS: Mummy not buy you a Gameboy? Aw, poor baby…

JAY: You couldn't take it.

MRS REYNOLDS: You have no idea, Jay, what I can take.

JAY: Bollocks.

MRS REYNOLDS: I sat with my husband
 For three days after his heart attack.
 Counting every breath.
 Watching the numbers on the machines.
 Nothing in Farenheit by then –

JAY: So what – he died, in hospital, nurses and doctors looking
 after him, you by his side?

MRS REYNOLDS: Yes.

JAY: Sounds nice.

MRS REYNOLDS doesn't answer.

JAY: Got no comeback for that? I'll say it again – sounds nice.
 Sounds like an alright way to end a life.
 Here's how I started mine.
 When I was little, all I remember is
 My mum, always sick
 And me worrying about her all the time.
 She had doctors coming every day
 To give her medicine.
 Except it wasn't medicine.
 And the men weren't really doctors.
 And sometimes she didn't have money.
 So she'd pay for 'her medicine' in other ways.
 There was this one bloke
 She called him Holliman
 I walked into the lounge one day
 Found mum on her knees, in front of him.
 I didn't know what it meant.
 After that, mum put a lock on my door
 On the outside.
 They used to lock me in – for my sake.
 Stop me seeing things I shouldn't.
 But they'd get so wasted, they'd forget I was there.
 One time I had to shit in the corner of my own room.
 I couldn't help myself.

I was seven. It was hurting my belly. Holliman
Rubbed my nose in it.
Held my face down
And rubbed my nose in my own shit.
Said that would teach me.
He would bring men round,
Let them use my mum.
Before they locked me in, mum
Would give me a pot noodle
And the kettle, so I could feed myself.
I would eat every mouthful and think –
See? My mum loves me, really.
One time I heard her screaming.
I kicked the door till the lock gave way
Holliman was standing over her, his foot
On her throat.
I stabbed him in the leg with my penknife.
And she –
– she threw me out.
I was thirteen.
And I don't look to her for nothing these days.
I just thank her.
For everything she taught me.
For how strong she made me.

JAY looks at MRS REYNOLDS.

JAY: Sorry, I didn't catch that.

MRS REYNOLDS: I didn't say anything.

JAY: No, you didn't.

MRS REYNOLDS: I think, this should all stop now.

JAY: Yes.

MRS REYNOLDS: So that's – it's all finished. The stuff about
you stealing my necklace –

JAY: The stuff about you framing me, for stealing your
necklace?

MRS REYNOLDS: We can forget that.

JAY: Oh can we? That's good to know.

MRS REYNOLDS: And we can just stop all this, you coming
here, working for me.

JAY: I knew I'd win.
And I have, haven't I?
Mrs R.

MRS REYNOLDS: Yes you've won.

JAY: I think I deserve
Some compensation
For the way you've treated me.
I'm talking about in cash terms now.
That is if you want me to go.

From one of her jute bags, MRS REYNOLDS gets out her purse.

JAY: Don't bother to count it,
I'll just take everything you've got.

MRS REYNOLDS offers a few notes.

JAY: Oh, very kind, thank you, don't mind if I do.

MRS REYNOLDS: Will you go now?

JAY: What's your name?
Like your first name.

MRS REYNOLDS: Anna.

JAY: Anna? Sounds like a retard's name.
No wonder you were such a fucking spastic all your life.

JAY goes.

MRS REYNOLDS sits down on the bench.

Rests her head in her hand for a moment.

Then gets up, suddenly stiff, like a much older woman.

Begins to tidy up the remains of the sunflower.

Loses heart, throws the bits of plant back in the flower bed.

Sits, slumps on the bench.

As she sits –

A lighting change. Day fades into night.

JAY comes back on. He's pacing, talking on his phone.

JAY: Kee? I've called you
Twenty times mate, come back at me.

(Dials again.)

Steve-o. Coming out?
Come on.
No?
No no, fair enough.
Alright mate.

(Hangs up: dials again.)

Naz mate, it's me.
You in town?
Fancy a quick one?
Forget about that, do it tomorrow.
Come on mate just one and I'll –
Yeah, no, don't worry about it.

(Hangs up: dials again.)

Boycey! What you up to?
What?
Well sod you then.

(Dials again.)

Trev. Trevor mate.

(Beat.)

Mate I can't understand you.
Mate you need to slow down…
No, no I don't know what that is.
Mate turn the music down and –
No there is music mate, I can hear it,
I can't hear you is the problem.
Trev, what've you had?
Trev stop calling me dad.
I'm not your dad, Trev –

(Hangs up; dials again.)

Damian!
You in the mood for a cheeky couple?
No? When d'you ever say no?
– don't you hang up on me, you little…

(But Damian has hung up. JAY hesitates, dials again.)

Hey Ricky.
It's Jay.
Jay.
Jay Kieran's mate.
Jay that hangs round with Boycey.
Jay that plays pool with Trev.
Jay from that time when you and Damien –
No I didn't.
No, I did not.
Then he's a liar, isn't he –

(Dials again.)

Kieran, mate, this is like
The fiftieth time, it's been
A nightmare of a day, I just –
I need –
I need you to pick up, man,

JAY dials again. A number he has to punch out with some care this time.

He waits. The pacing has stopped. He's still now: as is MRS REYNOLDS, on the bench.

There's an answer.

JAY: Yeah it's me.
　　Don't hang up.
　　Don't, please please please please.
　　I just wanted to –
　　– you okay? Yeah?
　　That's good. That's great. I'm fine.
　　Look I was thinking
　　Maybe I could come round.
　　No no no nothing like that.
　　Just for a day.
　　For an hour or two.
　　It's your birthday soon.
　　I could bring you a present.
　　Anything you want.
　　Or money yeah.
　　Money, if that's what you want.
　　If I could just come round.
　　Just for a cup of coffee.
　　Just for ten minutes.
　　Please. Can I.
　　Please.
　　Please.
　　Please,
　　Mum.

To black.

7.

MRS REYNOLDS' front garden.

MRS REYNOLDS emerges, begins potter around – pulling off diseased leaves, squirting at infested plants with a spray bottle of soapy water, rooting out weeds.

Then she turns.

MRS REYNOLDS: What do you want?

She's half-expecting an attack.

JAY: You know that money you gave me?
I spent it.
I need some more now.

MRS REYNOLDS: I haven't got any more money for you.

JAY: That's the problem, see –
You pay someone off,
They're gonna want paying again.
You have to stand up to people,
Or if you don't they basically fucking own you.
And d'you know what's annoying me,
About you?

MRS REYNOLDS: I just think –

JAY: *(Suddenly snarling.)* What? What?

MRS REYNOLDS recoils.

MRS REYNOLDS: I want you to go.

JAY: No.

MRS REYNOLDS: Please.

JAY: What you gonna do, call the police?

MRS REYNOLDS: I can't help you, Jay –

JAY: Of course you can't –
– help me?
How would you,
Help me?

MRS REYNOLDS: Because you're not just
A naughty little boy
Who's gone astray.

JAY: Oh, I am very naughty…

MRS REYNOLDS: You're broken.
 You were never made right.

 MRS REYNOLDS gathers up her things.

MRS REYNOLDS: Please don't bother me any more.
 I'm asking nicely.

 She goes inside.

 Shuts the front door behind her.

 JAY doesn't move.

JAY: I'm still here.

 (Raising his voice.)

 I'm still here, Mrs R.

 (Beat: then, really yelling.)

 I got no other pressing appointments to be at.

 In a flurry of movement, the door opens and MRS REYNOLDS comes out again.

 She has a phone in her hand.

MRS REYNOLDS: Alright then.
 I'll call the police.

JAY: Go on.

MRS REYNOLDS: I will.

JAY: Have me chucked inside,
 With all the scum,
 Cos that's where I belong.

 Stand-off.

JAY: Isn't it.

 She lowers the phone.

JAY: I'm not going away.

MRS REYNOLDS: I don't know what to do with you.

JAY: Just tell me something.
Give me something to do.
What were you doing?

MRS REYNOLDS: I was dead-heading the roses.

JAY: Then tell me to do that.

MRS REYNOLDS: I was dead-heading the roses, Jay.
You could help me with that.

JAY: Alright.
Alright then.
We're getting somewhere.

JAY comes into the garden, and gets to work on the rosebush.

MRS REYNOLDS watches him.

ACT TWO

1.

Music, and the quality of the daylight changes. We're moving into summer.

The flowerbed. There's litter everywhere, and the wall is fairly well covered with graffiti. It's mostly tags, declarations of love and hate, but there is also a prominent and skilfully painted flower, in a flower pot.

MRS REYNOLDS comes on with a bin bag, and gets to work on the litter.

JAY appears from the other side of stage at a run.

JAY: Sorry I'm late, again…

Runs straight off in the direction MRS REYNOLDS appeared from.

MRS REYNOLDS: You're not, you can –

JAY reappears, now with a tin of paint and a brush.

MRS REYNOLDS: You can turn up when you like.

JAY: Nah, ten's good. I mean I say that and then I'm late every day but – ten's good as a target, like.

MRS REYNOLDS watches him for a bit as he begins to paint.

MRS REYNOLDS: Looks like someone's joining in.

JAY: Sorry?

MRS REYNOLDS: We're trying to grow flowers in the flower bed, someone's drawn a flower on the wall. Almost a pity to paint over it.

JAY: Then – don't. Leave the flower. If you like it – why not?

MRS REYNOLDS: Because it's vandalism.

JAY: But – you like it.

MRS REYNOLDS: Well, more than the other stuff.

JAY: It makes the place better.

MRS REYNOLDS: Well I suppose it does.

JAY: So let's get rid of everything else, and leave the flower up.

MRS REYNOLDS nods. JAY paints, skirting round the flower. MRS REYNOLDS watches him for a while, and then leaves.

Time shifts while JAY finishes the painting. Summer reaches its height. The flower surrounded by white, JAY leaves the stage.

Music, and the lights shift. There are a couple more pictures on the wall.

Jay returns, with a bin bag and one of those grabbing devices that allow you to pick up rubbish without bending.

He moves around the stage, listening to music on headphones, nimbly picking up bits of litter with the grabber.

MEL enters.

MEL: Hi.

JAY: Alright.

MEL: Hi, I was wondering if you could help me out?

JAY: *(Taking off his headphones.)* Sorry?

MEL: Yeah I've just moved in over the road and the front garden, there's just a lot of bin bags and old chairs and a fridge and an ironing board and – *(Realises she's babbling.)* all the usual rubbish. You probably don't need to know… every single item.

JAY: Right.

MEL: And I was wondering if you could… help?

JAY: *(Meaning the grabber.)* With this?

MEL: No, no, sorry, no, I meant maybe you could – radio to base?

JAY: I'm not sure / what you

MEL: / Cause you do pick stuff like that up, don't you?

JAY: Not – no.

MEL: It says you do on your website.

MRS REYNOLDS arrives.

MRS REYNOLDS: Oh hello, I know you, don't I.

MEL: I don't think we've met…

MRS REYNOLDS: You're the young lady who's just moved in across the road.

MEL: Well yes okay then, I am.

MRS REYNOLDS offers her hands.

MRS REYNOLDS: I'm Mrs Reynolds.

MEL: Mel.

MRS REYNOLDS: How are you finding things so far, Mel?

MEL: I was just hoping our friend here might help me shift a few things from the front garden, but, he doesn't seem too keen.

MRS REYNOLDS: Oh wonderful, cause it's a real eyesore, isn't it. I mean I'm not blaming you. It's a shared house and you've only just moved in, but still –

MEL: No, I know.

MRS REYNOLDS: But I don't think Jay'll be able to do much. You need to ring the council. They'll collect all that stuff, which makes it all the more bloody annoying people just leave it to sit there…

MEL: Doesn't he – oh God – doesn't he work for the council?

MRS REYNOLDS: Jay? Good grief, no!

MEL: Sorry, I just saw him clearing up, and –

(Realising she's talking about JAY while he stands there.)

I just walked up and started ordering you about. What must you've thought?

MRS REYNOLDS: I'm sure he thought, here's a lovely young woman coming to speak to me – and he will have been very happy about that.

JAY: I can talk, you know.

MRS REYNOLDS: Now, let me get you the number for the waste disposal department…

MRS REYNOLDS leads MEL off.

MEL: Nice to meet you, Jay. And sorry for – you know.

JAY watches the women leave. Once they are gone –

JAY: Absolutely no problem at all. Mel.

He puts back on his headphones, gets back to picking litter.

Time starts to shift again. Music. Summer ripens towards autumn.

MRS REYNOLDS and JAY survey newly scrawled messages on the wall.

MRS REYNOLDS: Well, that can go. That can go. That can definitely go.

JAY: What about this?

MRS REYNOLDS: *(Reads.)* 'Steve and Ali – true love – four years of love.' I like that. We'll keep it.

JAY: Passes the Mrs R taste and decency test?

MRS REYNOLDS: The day these so-called 'graffiti artists' start asking permission to spray in my street, then I'll start consulting on what I whitewash.

JAY: Oh you're painting these out yourself, are you?

KIERAN enters.

KIERAN: Alright.

JAY: Alright mate.

They shake.

MRS REYNOLDS: Good morning, Kieran.

KIERAN: Is it?

MRS REYNOLDS: Oh well done, very good.

KIERAN: Just asking a question.

JAY: So what you up to, mate?

KIERAN: Fuck all.

MRS REYNOLDS: Gosh, that sounds exciting.

JAY: Mrs R…

MRS REYNOLDS: Yes, Master J?

JAY: Just…

Mrs R takes the hint; backs off slightly.

KIERAN: You hanging here, are you?

JAY: For a bit.

KIERAN: How long's this going on for?

JAY: Hard to say, mate.

KIERAN: So: how many hours'd they give you?

JAY: Like… hundreds.

KIERAN: You been doing it for months...

JAY: Yeah but she only wants me a half hour a day sometimes, so it takes forever to make up the time.

KIERAN: Stupid cow.

JAY: Tell me about it...

MRS REYNOLDS: If you're going to lurk, Kieran you could make yourself useful.

KIERAN: Yeah, right.

MRS REYNOLDS: Jay says you're a dab hand with a spray can. Why not fill up all the blank spaces on that wall?

KIERAN: If you want...

MRS REYNOLDS: Not with filth. With...

KIERAN: Pretty flowers?

MRS REYNOLDS: If you like.

KIERAN: And how much do I get for it?

MRS REYNOLDS: Get for it?

KIERAN: No pay, no play.

MRS REYNOLDS: You might do it just to make the place look a little better.

KIERAN: *(Beat.)* Are you mentally retarded?

JAY: Kee...

MRS REYNOLDS: Jay's happy enough to help out for free.

KIERAN: Jay 'helps out' cause the filth make him.

MRS REYNOLDS: *(Beat.)* Well of course there is that.

KIERAN: *(To JAY.)* Laters, man.

> *They shake, and KIERAN goes.*

JAY gets on with white-washing.

MRS REYNOLDS: You tell your friends you help me because you have to.

JAY: I don't tell them nothing.

MRS REYNOLDS: But they assume. And you don't correct them.

JAY: And?

MRS REYNOLDS: And –

(Beat.)

And that's fine.
Look: I wanted to give you these.

She gets an envelope from her pocket, gives it to JAY.

He looks inside.

MRS REYNOLDS: They're seeds. From the first sweet peas.

JAY: The ones with the smell?

MRS REYNOLDS: Plant them now or keep them somewhere dry over the winter and sow them in the spring.

JAY: I haven't got no garden.

MRS REYNOLDS: Your nan's flat: you said she's got a little balcony. Plant them in pots, grow them up the railings. Bet she'd love that.

JAY: Yeah. See when I say, I live at my nan's, I do – but it's more I sleep there? Like I can't come in before eleven, and I crash in the lounge, and I've gotta be gone before she gets up? Which is alright actually cause she never really surfaces before midday...

He hands the seed packet back.

JAY: So probably best you keep them.

2.

Time has passed. Now we're well into autumn.

MRS REYNOLDS: Jobs in September are
 Pruning, cutting back dead growth,
 Planting bulbs for spring, then
 Dressing the soil with compost
 Or richly-rotted manure, which
 The frost will break down for us
 Over the winter.

JAY: If we get any frost.

MRS REYNOLDS: And if we don't, you can dig the manure in
 come New Year.
 So. Bulbs.

JAY: They go in the ground.

She shows him a bulb.

MRS REYNOLDS: You see this side?
 That's where the shoots come from.
 So you plant it with that side up. Then
 On the bottom, these little straggly things
 Are the roots.

JAY: And you put them face down.

MRS REYNOLDS: That's right.

JAY: Look a bit like onions, don't they.

MRS REYNOLDS: I wouldn't eat them, though.

JAY: They poisonous?

MRS REYNOLDS: No, because if you do, I'll give you a clip
 round the ear.

MEL walks by.

MEL: Hello.

MRS REYNOLDS: Lovely morning.

MEL: Gardening again.

MRS REYNOLDS: Yes we are!

MEL: Sorry – obviously you are. I mean I saw you, on my way
– I was in the grocers just now, they had these plants they
were just giving away and I thought you might want them.

MRS REYNOLDS: That's very kind of you, but I don't think
I've got an inch of space.

MEL: Oh no I meant – for the flowerbed, down the road. I've
seen you, looking after it.
And then I've seen kids destroying it. Must be costing you
a bomb to keep buying new plants –

MRS REYNOLDS: You've seen kids vandalising the flower bed?

MEL: Well… yeah.

MRS REYNOLDS: And you… shouted at them? Called the
police?

MEL: I didn't see them, really – I was in my flat. I saw them
through the window. I didn't think to –

MRS REYNOLDS: Do anything?

MEL: Well… no.

MRS REYNOLDS: Of course not. Why on God's earth would
anyone do anything…

JAY: Mrs R.

MRS REYNOLDS: What?

JAY looks at her.

JAY: She brought you some plants. Remember?

MRS REYNOLDS: *(Beat.)* Sorry. Ignore me. Pounding
headache. Just nipping inside for some aspirin.

MRS REYNOLDS puts down her tools and goes.

MEL: Bit fierce, isn't she.

JAY: She has her moments.

MEL: "It's Mrs Reynolds' street, the rest of us just live here." That's what I was told.

JAY: Who by?

MEL: I don't dare say, don't want to get them in trouble. Seems to like you, though.

JAY: I'm a likeable guy.

MEL: Are you, really?

JAY looks at MEL. MEL holds his gaze. JAY looks away.

JAY: Anyway I'd best be getting on...

MEL offers up the bag.

MEL: So these plants...

JAY takes the bag from her.

JAY: Yeah sure. *(He takes a look.)* Yeah the thing with these is they're what you call summer bedding plants? You put them in say the spring, the start of the summer? But now it's –

MEL: – the end of the summer?

JAY: Which, to be honest, is probably why they were giving them away.

MEL: Cause they're no good.

JAY: Stick them in your garden, never know, they might grow again in the spring.

MEL: Yeah, I might. *(Beat.)* I wouldn't know how though, I'd kill them straight off.

JAY: Soak the plant in the pot,
 Dig a hole, loosen the earth
 In the bottom,
 Pull the plant out of the pot,
 – it'll come easy 'cos you soaked it –
 Loosen the root ball,
 Stick it in the hole,
 Firm the earth around it
 And water in well.

MEL: Okay…

JAY: Easy really.

MRS REYNOLDS enters.

JAY: Mrs R, I was just saying, she might as well stick these in her garden, see if anything comes up in the spring.

MEL: I was explaining to Jay I wouldn't have a clue how to do that.

JAY: And I was just saying to her, it's the simplest thing…

MRS REYNOLDS: I see…

MRS REYNOLDS is very aware of the way MEL is looking at JAY.

MEL: And I would give it a go but our garden's split between the three flats you see so no-one really bothers and it's all over-grown with massive brambles and nettles and things, so… be a bit of a waste, really.

JAY: No problem at all.

JAY picks up a billhook and offers it to her.

JAY: Billhook'll sort that out for you.

MEL: Right…

MEL takes the billhook, hefts it. Looks to MRS REYNOLDS.

MEL: Well, thanks for that. I'll get it back to you *(The billhook.)* soon as I can.

MEL goes.

JAY gets back to work.

MRS REYNOLDS: Not your type, then?

JAY: What?

MRS REYNOLDS: Mel. Who was clearly angling to get you to come round and give her a hand.

JAY: I know, cheeky bitch.

MRS REYNOLDS: No, not because – good God, how does the race perpetuate itself? She likes you.

JAY: *(Beat.)* Oh yeah I know that.

MRS REYNOLDS: Oh for goodness sake…

MRS REYNOLDS gets on with some little task, so she's not looking at JAY.

JAY: No no I mean – I knew she did, obviously. Just – good to get a female perspective.

MRS REYNOLDS: *(Still without looking at him.)* You going to then?

JAY: If Mel wants a little sugar from the Jay-meister
Who am I, to deny?

MRS REYNOLDS stops what she's doing and looks at him.

JAY: What?

MRS REYNOLDS shakes her head, gets back to her task.

3.

MEL's garden.

JAY, flushed from hacking back weeds. Carrying a billhook. MEL enters, with some cans.

JAY: That's the worst of it done.

MEL: You want a drink?

JAY: Please.

MEL offers him a can of lager.

JAY: Cheers.

JAY cracks open the can, and drinks deeply. MEL watches.

MEL: Hit the spot?

JAY: Oh yeah.

He drinks again. MEL watches again. JAY becomes aware of her watching.

JAY: What?

MEL: Thirsty then?

JAY: Thirsty work.

MEL: You shouldn't quench a thirst with booze. Bad for you.

JAY offers the empty can.

JAY: I haven't. Still parched.

MEL offers him another can.

JAY: Anybody'd think you were trying to get me drunk...

MEL: You're full of yourself.

JAY: It's all a front.

MEL: No it isn't.

JAY: *(Beat.)* Nah, it's not.

MEL opens a can.

MEL: I remember the first time I saw you.
I remember thinking – what an idiot.

JAY: Oh, cheers...

MEL: No no, it was cause you were painting over graffiti
And I thought, why's he bothering with that?
Kids'll just come do more, the little bastards.
And all those plants you stuck in the flowerbed?
They all got pulled up and ripped to shreds
I remember getting annoyed with you.

JAY: I annoyed you, before you even knew me?
That might actually be a record.

MEL: Exactly, you were just – some guy
On the street, who I didn't even know
And you were so pissing me off.
I remember thinking
Just stop it, just stop even trying
Why are you wasting
All that effort, all that time –

JAY: – all those plants.

MEL: There was once
It must've been you planted seeds
Rather than sticking plants in,
Because they came up, slowly,
Little buds at first then a few leaves…

JAY: The nasturtiums.

MEL: And they actually survived for ages,
It was like 'cause they grew, gradually,
The kids didn't notice them, not
Till they got quite big and then –

JAY: Then the kids did notice them.

MEL: I came past one morning and
There were all the leaves and stalks
Just thrown around. I was so sad.
Then you came out, gathered all the bits up.
Not annoyed. Not angry.
Just started again.
Just planted new seeds.

I was watching you from my window.
I remember thinking –

(Beat.)

And then I saw you helping Mrs Reynolds
With her garden as well and I thought,
What a sweetheart, helping that –

JAY: Grumpy old bag?

MEL: Helping that grumpy old bag
With her garden. What a star.

JAY: It's just now and again.

MEL: It's every day! I see you, every bloody day.

JAY: Spend a lot of time watching me, then?

MEL: S'pose I do, yeah.

JAY: That's a bit weird, isn't it?

MEL: Is it weird? Or is it, just…

JAY: What?

MEL: Just, when I was younger
I was into troublemakers, you know,
Bad boys. And now – a guy like you.

JAY: A guy like me what?

MEL: Now… I'm into a guy like you.

JAY: Are you?

MEL: You know it. You do.
And this is maybe the moment to say
You might be into
A girl like me, too.

MEL waits for him to say something. He just takes a drink.

JAY: Some people would tell you
 I'm a troublemaker.

MEL: Oh yeah you definitely look it,
 Picking up litter and hanging out
 With old ladies.

JAY says nothing.

MEL: What I really like about you
 Is that you keep coming back.
 Day after day.
 You're not full of shit,
 In the way most guys, you know,
 Really really are.

 (Beat.)

 And any time you feel like
 You want to come over here
 And kiss me, then,
 You should probably just do that.

JAY looks at her. And smiles.

4.

The flowerbed. Later the same night.

KIERAN is at work. He's sprayed the letters 'F' and 'U', and is working on a 'C', making them big enough that the finished four-letter word will cover the whole wall.

JAY enters, walking home from MEL's. He watches for a while, silent.

JAY: Alright, mate.

KIERAN: Jesus Christ, I nearly shat myself then.

JAY: What you up to?

Kieran *(Beat.)* What's it look like?

JAY: You know she'll make me paint over that.

KIERAN: She can't make you do anything.

JAY says nothing.

KIERAN: Where you been?

JAY: Only on an actual real-life date.

KIERAN: What?

JAY: Dinner, and wine, and the whole shebang.

KIERAN: I thought you looked chuffed with yourself.
 You do the deed?

JAY: Might've.

KIERAN: That's a no then.

JAY: Just playing it slow.

KIERAN: And who is the lucky blind girl?

JAY: You know that Mel?

KIERAN: Just moved in over there?

JAY: That's the one.

KIERAN: Are you shitting me?

JAY: What?

KIERAN: Mate, she has been round the place like a rash.

JAY: Piss off.

KIERAN: Parachute Mel, everyone gets a jump.

JAY: You've got her mixed up, mate.

KIERAN: She's done Robbie, she's done Trev, she's done Naz,
 she's done Naz's little cousin.
 She's done Will, she's done Brett.

JAY: No way.

KIERAN: Oh my God: she's done Steve Olson. I've seen the photos on his phone.

JAY says nothing.

KIERAN: And I mean, he's a sick bastard.
You know the stuff he does.
Imagine that. Going with a girl
After he's had her.
It'd be like you were
Steve Olson's bitch.

(Beat.)

Seeing her again?

JAY: Shut it, Kee.

KIERAN: Maybe take her to a movie?
Maybe take in a show?
Treat her real nice.
After Steve-o's treated her
Like meat.
Or maybe Steve-o'll be taking her out.
And you'll be sitting home looking after her kid.

(Beat.)

She did tell you that, didn't she?
Of course she did:
On your actual date.
She's got a kid,
And she gave it up.
I mean you did know that, didn't you mate?

JAY: *(Beat.)* I'll see you – mate.

JAY moves off abruptly. For once they part without shaking hands.

KIERAN: See you, Jay.

KIERAN stands. Picks up his aerosol, gives it a shake.

Gets back to spraying.

5.

Next day. The flowerbed. JAY is whitewashing the wall.

MRS REYNOLDS is struggling to pick up litter with the grabber.

She gives up. Stretches her fingers.

MRS REYNOLDS: Do you want to swap?

> *She offers him the litter-grabber. JAY doesn't respond.*

MRS REYNOLDS: Jay?

JAY: *(Snapping.)* What?

> *MRS REYNOLDS looks at him.*

JAY: I've known him since I was three.

MRS REYNOLDS: You're telling me Kieran's never lied to you?

JAY: Not about anything that matters.

> *MEL enters.*

MEL: Morning all.

MRS REYNOLDS: Ah, right. We'll get this sorted out now.

MEL: Oh God, what've I done?

MRS REYNOLDS: You've done nothing, my love. But someone else has been feeding Jay's head with stories.

JAY: Mrs R…

MEL: What stories?

JAY: Seriously, drop it.

MRS REYNOLDS: Best these things are out in the open.

JAY: Maybe not out in the street, though.

MRS REYNOLDS: Will you just – trust me? For once?

MEL: You're panicking me now.

MRS REYNOLDS: It's nothing to fret about. Just a silly little friend of Jay's getting a bit jealous, spreading a bit of muck.

MEL: What sort of muck?

MRS REYNOLDS: Let's just say he was besmirching your reputation.

JAY: He said you had a kid. But you gave it up.

MEL: Right.

MRS REYNOLDS: It's almost sweet, him trying
To come between you 'cause
He wants Jay all to himself.
Mel?
Mel says nothing.

MRS REYNOLDS realises she's put her foot in it.

MRS REYNOLDS: Oh... bollocks.
Right, I'm going to pop back to the house...

MRS REYNOLDS vanishes.

A pause.

MEL gets out a photo.

MEL: That's him. Mikey.

JAY: Cute, yeah.

JAY hands the photo back, returns to whitewashing the wall.

MEL: After he was born,
Things weren't easy.
I got into a bit of a mess.
I just wanted to be a good mum
And I couldn't.

JAY doesn't respond, just keeps on painting.

MEL: The doctors said
It was post-natal depression.

I couldn't look after him, 'cause
I was in such a state myself.
My mum and dad took him.
We decided they'd have him
Till I was back on my feet.
That was two years ago, now.

JAY keeps working.

MEL: Is that even the bit that bothers you?
I bet it's not.
I bet it's the other stuff.

JAY stops what he's doing.

MEL: Well whatever your mate told you.
It's probably true.
When I was feeling bad
When I was feeling such a complete failure,
I'd go out, and knowing I could pull,
I could make some man want me,
Well it helped. It kept me going.

(Beat.)

Or at least to start with.
After a bit it made me feel
Like I was giving my self away.

JAY gets back to painting.

JAY: *(Without looking at her.)* Yeah well you were.

MEL: And you've hardly been
A choirboy, have you?

She watches him.

MEL: I'm complete disaster
As a mum, that you can swallow –
– but what actually bothers you is
I've shagged some blokes
You might see down the pub.

You're thinking about it now:
Who they were.
What I did with them.
Well the answer is – I did
Pretty much everything, to anybody.
And I'm not happy about it.
I'm certainly not proud.

And now the wall is completely white again. But JAY still cannot look at her.

MEL: Do you even like me?

JAY: Why would I give a toss, if I didn't like you?

MEL: I like you, as well.

JAY: It's different, with boys,
When another boy's had your girl,
It's too much.

MEL: Then be a man.
Be a man, and tell me
None of that stuff matters.

Finally he turns to her.

JAY: Look at you.

MEL: What? What?

JAY: You're lovely.

MEL: Am I?

JAY: Yeah. Yeah you are.

MEL: That's nice to hear.

JAY: What you doing Saturday?

MEL: Hanging out with my son.

JAY: Okay.

MEL: You could tag along.
 If you wanted.

6.

MRS REYNOLDS' front garden. Night. Several weeks later.

MEL walks up to the front door, knocks.

No response.

MEL: Mrs R?

 Was there a noise inside?

MEL: Mrs R was that you?

 MEL listens carefully. She pushes open the letterbox.

MEL: Mrs R are you alright?

 (Beat.)

 Oh my God! Mrs R…

 The door opens.

MRS REYNOLDS: I'm fine, I'm fine.

 MRS REYNOLDS is looking dishevelled.

MEL: What happened?

MRS REYNOLDS: Just need a bit of air.

 When she moves, we see she's limping.

MEL: What've you done?

MRS REYNOLDS: Nothing!

 (Beat.)

 Sorry.

MEL: That's alright.

MRS REYNOLDS: It's my own bloody fault. I never bother with Christmas and I thought, this year, might as well, and I remembered stuffing decorations up on top of the wardrobe, I was reaching to get them –

MEL: You should use the step-ladder when you're reaching / for things

MRS REYNOLDS: / I bloody was. I'm not an idiot.

(Beat.)

Sorry. Again.

MEL: It's alright. Again.

MRS REYNOLDS: I was using the step-ladder. My leg gave way.

MEL: But you're okay? In yourself?

MRS REYNOLDS: *(About to snap.)* Yes, I'm –

MRS REYNOLDS catches herself.

MRS REYNOLDS: I'm fine. Thank you very much for your concern.

MEL: No problem.

MRS REYNOLDS: Serves me right, fussing around with decorations when it's just me on my own…

MEL: It's nice to make a bit of an effort.

MRS REYNOLDS: I did think… maybe you and Jay and Mikey could come round for Christmas dinner, if you're / not

MEL: / No, I'd like that. And Jay – it'd be free food, so…

MRS REYNOLDS: Well that's lucky 'cause to be honest I've already ordered the turkey – oh. You wanted something, didn't you.

MEL: Not really –

MRS REYNOLDS: And hark at me, rabbitting on…

MEL: You've had a shock.

MRS REYNOLDS: What can I do for you?

MEL: Jay was supposed to be round at seven and –

MRS REYNOLDS: And you wondered if I had him stuck here doing jobs for me?

MEL: I wondered… if you'd seen him, is all?

MRS REYNOLDS: I haven't, as it happens, not today. Have you tried –

(She pulls up.)

Yes, of course you've tried phoning.

MEL: A couple of times, I don't want to hassle him but…

From off, the sound of JAY singing 'We Wish You a Merry Christmas'.

MRS REYNOLDS: Ah. Somebody's had an early dose of Christmas cheer…

JAY staggers on, still singing. One hand under his jacket.

MEL moves towards him.

MRS REYNOLDS: Does no-one know any proper carols any more? That's all you ever hear, 'we wish you a merry Christmas', on and on, what about the old songs, / Good King Wenceslas…

MEL: / Look at the state of you.

JAY: And look… at the state of you too.

MEL: You are a wreck.

JAY: You are gorgeous.

MEL: Where've you been?

JAY: *(Beat.)* On adventures.

MEL: With who?

JAY: Mates.

MEL: I phoned all your mates.

JAY: I was out – with new mates. Who were not mates at the start of the night. They are now.

MEL: I said I was going to cook.

JAY: Brilliant, I'm starving.

MEL: I was going to cook for seven o'clock.

JAY: Alright, Mrs R?

MRS REYNOLDS: Oh I'm fine.

JAY: *(To Mrs Reynolds.)* You wanna get in, it's freezing out here.

MEL: I was cooking for seven. It's quarter past ten.

JAY looks at her for a long time. Then, almost excitedly –

JAY: Is it?

MEL: Yeah.

JAY: No way.

MEL: And what's that on your trousers, is it piss or vomit?

JAY looks down at his trousers. He considers. Then announces, with huge dignity.

JAY: Neither of the above.

MEL: You've had such a great time with your mates, you get back to them –

JAY: Mel –

JAY extends his hand towards her, tries to cup her cheek. She pushes him away.

JAY: Don't be like that...

MEL: Get lost.

MEL realises there's something wet on her cheek, where JAY touched her.

MEL: Urrr, what the hell is this?

She dabs at her cheek. Sniffs her fingers.

MEL: Jay...

JAY: Come on, let's be nice. Don't you wanna be nice?

MEL: What's happened to you?

MRS REYNOLDS: What is it?

JAY: Can we go in please cause I'm really freezing.

MEL catches JAY's hand.

MEL: Oh my God that's blood. Jay.

MEL opens his jacket. The bottom half of his shirt is drenched in blood.

JAY: I might have to sit down.

JAY slides to the floor.

MRS REYNOLDS: I'll get an ambulance.

MRS REYNOLDS heads inside to phone.

JAY: Just gonna lie down for a bit...

MEL takes off her coat, lays it over him.

MEL: No, listen, you can't.
You can't sleep, baby.
You have to stay awake.
Jay. You have to stay with me.

To black.

7.

MRS REYNOLDS' living room. Something of a spread on the table.

MRS REYNOLDS leads MEL and JAY in.

JAY straight away heads to the table and starts picking.

JAY: *(Of the spread.)* This is a bit much, isn't it.

MRS REYNOLDS: Christmas leftovers. All got to be eaten before it goes off.

JAY: You really go to town, don't you.

MRS REYNOLDS: Not normally. This year... I was planning to have people round.

JAY: Anyone I know?

Mrs Reynolds looks at him.

JAY: Oh right me.

MEL: Who else d'you think?

JAY: *(To Mel.)* Her kids could've been coming home.

MRS REYNOLDS: It was going to be you, and Mel, and Mikey.

JAY: Alright, sorry to ruin everyone's plans by selfishly getting stabbed...
(Off MEL's look.) What? *(To MRS REYNOLDS.)* I'll see what I can do to get rid of this little lot now. And, you know, there's always next year.

MRS REYNOLDS: *(Beat.)* Yes there is.

A knock at the door.

MRS REYNOLDS: I'll go.

JAY: Who's that?

MEL: Dunno.

JAY: *(Sensing something is up.)* Really...

MEL: Let me have a look at your dressing.

JAY: My dressing's alright.

MEL: So what's it matter if I have a look?

JAY: No.

MEL: Jay...

They stare at each other. Then with huge weariness –

JAY: Alright...

JAY pulls up his shirt – a big bandage taped to his stomach, tape winding right round him to hold it on.

MEL: That looks fine. Don't know what you're making such a fuss about...

MRS REYNOLDS enters. And with her, CASSIE.

JAY: Looks like I've been set up again...

MRS REYNOLDS: I asked Cassie to come here / today...

JAY: *(To MEL.)* / You were in on this, weren't you?

MEL: You got stabbed, Jay.

MRS REYNOLDS: And we don't feel you're taking it seriously enough.

JAY: Don't we, really.

MRS REYNOLDS: Oh / for goodness' sake...

MEL: / Jay...

JAY: *(To CASSIE.)* You got anything to say for yourself?

CASSIE: Yes. As it happens.

MRS REYNOLDS: And actually listen.

JAY: Will you give me a break for one second?

CASSIE waits for silence.

CASSIE: You might remember, we talked about how hard it is for people to get out of offending behaviour once they're involved with the criminal justice system.

JAY: You might've talked about that, don't think I did.

JAY is aware that MEL and MRS REYNOLDS are deeply unimpressed by him right now.

JAY: Okay, get on with it.

CASSIE: You start with the best intentions in the world but you're walking the same streets, seeing the same people –

JAY: I'm not seeing the same people.

MRS REYNOLDS: You got stabbed.

JAY: Yeah. That's right.
Someone stabbed me.
Not me doing the stabbing.

CASSIE: So there's someone out there now who stabbed you.

JAY: And perhaps he should be getting your attention.

MEL: So it was a he?

JAY: *(Beat.)* Yeah. I'm guessing.

MEL: You said you couldn't remember a thing.

JAY: It wasn't anyone I knew.

MEL: How do you know that, if you can't remember a thing about what happened?

MRS REYNOLDS: Would you remember his face if you saw him again?

JAY: They're never gonna catch him, are they?

CASSIE: But if you saw him, you'd recognise him.

JAY: Might do.

MEL: So if you saw him down the pub you'd know his face.

JAY: Maybe.

CASSIE: And what then, Jay?

MEL: What'll you do
When you see this guy again?

JAY: Nothing.

CASSIE: Nothing?

JAY: Just mind my own business.

CASSIE: You'd let him get away with it?

JAY: Alright – I'd dial 999. Is that what I'm supposed to say?

CASSIE: You're not supposed to say anything.
I'm asking you to think about
What you would actually do,
And what the consequences of those actions
Might be.

JAY: That is bollocks because you've all decided
What I'm supposed to say
And what I'm supposed to do, so
Why don't you just spit it out.

MEL: If we were a couple.

JAY: We are a couple. I thought.

MEL: A couple living together.

JAY: Where'd we live? There's no room at / yours

MRS REYNOLDS: / Jay – just listen.

MEL: And then if I took Mikey back we could go on the
housing list.

JAY: So?

CASSIE: Obviously there can be quite a wait till you get
somewhere but there are schemes –

JAY: There are always bloody schemes…

CASSIE: – there are places in the north with houses standing empty.

MRS REYNOLDS: So you could have somewhere a lot quicker.

MEL: And you, and me, and Mikey would be a family.

CASSIE: And you'd be away from the people and places and situations, that might lead you into trouble.

JAY: Right.

CASSIE: I know it's a lot to take in…

JAY: When you say, places in the north –
– do you mean, shitholes?

A look between the women.

JAY: It just strikes me that if there are houses standing empty
It's cos no bastard wants to live in them.

MEL: Jay…

MRS REYNOLDS: What if you and Mel just go and take a look?

CASSIE: In fact the council will pay for you to visit the area for a day.

JAY: *(Beat.)* No.

MEL: You won't even do
This one thing for me?

JAY: It was for you, you silly bitch.

MEL: What was?

JAY: The guy, in the pub.
Saying I'd taken on
Some slag and her little bastard.
He called you a slag,
I took him outside.

MEL: And he stabbed you.

JAY: Yes.

MEL: You could've died.

JAY: I didn't know
 He had a knife, did I?

MEL: Three inches higher,
 You would've died.

JAY: It was for you.

MEL: No it was not.

JAY: What I'm getting stabbed
 For my own benefit? Brilliant Christmas I had,
 Eating hospital crap and eyeing up the matrons.
 Probably see if I can't
 Can get myself shot for Easter.

MEL: Am I a slag?

JAY: *(Beat.)* Anyone who calls my girl a slag
 Is dead.

MEL: I don't give a toss
 What some wanker down the pub says.

JAY: Well I do.

MEL: Yeah, exactly.

 A beat between them.

JAY: I can't believe you're not
 Even a little bit grateful.
 Or flattered. Or something.

MEL: What do I tell Mikey
 When you come home from the pub dead?

JAY: I come home from the pub dead, then –
 – I must've become a zombie so

You tell him he has to burn me
Or shoot me in the head.

MEL: Don't you dare joke about this.

JAY: Don't you dare use that boy
 To blackmail me.
 Cos then I might lose my temper.
 I might do that.

CASSIE: Can I make a suggestion?

MRS REYNOLDS: Perhaps you better had.

CASSIE: My suggestion is –
 – that we just stop.
 Because as the emotional temperature rises
 It gets harder for any of us
 To make rational decisions.

JAY: This is my town.
 This is where I grew up.
 It's not like I'm going out
 Looking for trouble –

(More specifically to MEL.)

You're asking me to run.
And I don't do that.
I do not run away.
If you thought for one second
I ever could, then
You've got the wrong idea about me.
And you have definitely got
The wrong idea about us.

MEL looks at him. Then gets up – leaves without a word.

CASSIE: I'll – [unsaid: go after her]

MRS REYNOLDS: Yeah.

CASSIE leaves, following MEL.

JAY and MRS REYNOLDS sit for a moment. Then –

JAY: What?

MRS REYNOLDS: Well, that went –
– exactly how it was always going to.

JAY: Why'd you bother then?
Me leave town? As if…

MRS REYNOLDS: That girl loves you. She looks at you, she sees
Only the good. Only what you are now.
Nothing of what went into you.
Nothing of the past.

JAY: Well I'm not –

He stops.

JAY: Come on, Mrs R.

MRS REYNOLDS: What?

JAY: I'm not like I used to be. Am I?

MRS REYNOLDS is suddenly terribly upset. But she controls it.

JAY: What's all this?

He moves towards her.

MRS REYNOLDS: Don't. I'm perfectly fine.
I was a silly old woman.
And I hoped
You had grown up a bit.
But what do we learn in the garden?
Bad seed doesn't grow at all.

(Beat.)

You can't help the way they made you, Jay.

He stands back.

JAY: Fuck you, Anna.

8.

The flowerbed. Night. KIERAN and JAY are graffiti-ing the wall, passing spray cans between them.

JAY: I'm sitting there,
 My life being carved up
 In front of me.
 And suddenly I'm like –
 – what? What is this?
 How did this happen?
 Kieran You got pussy whipped, mate.
 Happens to the best of us.
 Not me, obviously.

JAY: And I'm thinking –
 – I took a knife?
 For this crap?

KIERAN: So that's it then? You and Smell, done with?

JAY: Yeah.

KIERAN: I might have a crack at that, then. Yeah she's a slag but still – you would.

JAY looks at him.

JAY: Whatever.

KIERAN: I'm shitting you, you twat.

 (Beat.)

 Wouldn't touch Steve Olson's sloppy seconds with yours.

JAY snatches a spray can from KIERAN.

JAY: Oh, that is funny, mate.

KIERAN: watches Jay paint.

KIERAN: Tell you what is funny.

JAY: What?

KIERAN: That splashback Nathan Mitchell.

JAY stops what he's doing.

KIERAN: I saw him,
Coming out of Valentino's night before last.
He was wrecked. Staggering.
He turns down some alley for a piss
And while he was there, acorn-dick in hand,
I came up behind him
And slammed his head into the wall.
Then stamped on him a bit,
Gave him a one-two-three-four to the nuts.

JAY: You didn't have to do that.

KIERAN: I know mate.

JAY: No, I mean it.

KIERAN: Course I'm gonna – *(Stops, genuinely confused at JAY's response.)* Aren't you still on probation?

JAY: Yes…

KIERAN: Then you need to stay out of trouble for a bit.

JAY: He's my problem.

KIERAN: So what, he stabs you, and he gets away with it?

JAY: I was waiting for my moment.

KIERAN: Yeah yeah yeah except how it looks is –
– he stabs you, and he gets away with it.
Then every other little shit thinks he can have a pop.
Now – a message has been sent.

JAY: I owe you, mate.

KIERAN shrugs.

KIERAN: You'd do it for me.

They shake. JAY pulls it into a hug. When they break –

KIERAN: You filthy poof.

9.

MRS REYNOLDS' living room. JAY is waiting.

On the table, a bottle of Scotch and a couple of tumblers.

MRS REYNOLDS comes in, and hands over a carrier bag.

JAY: *(Indicating the bottle.)* Started early, did we?

MRS REYNOLDS: There you go.

JAY: What's all this?

MRS REYNOLDS: Possessions. Of yours. Which you abandoned at Mel's.

JAY makes to go.

JAY: Alright, see you then.

MRS REYNOLDS: Stay for a cup of tea?

JAY: Don't drink tea.

MRS REYNOLDS: Or coffee, whatever you want.

JAY: Nah, I'm a bit – on my way somewhere.

MRS REYNOLDS: Mel says you just stopped coming round. Stopped phoning. She hasn't seen you in weeks.

JAY: Been busy.

MRS REYNOLDS: Too busy to phone?

JAY: Seems that way, yeah.

MRS REYNOLDS: You could've finished it with her face to face. Shown a bit of backbone.

JAY: Anything else you wanna lecture me about? Didn't brush my teeth this morning, if you're interested...

MRS REYNOLDS: I didn't mean to hector.

JAY: Apology accepted.

(Looking into the bag.)

Half this stuff isn't even mine – who else has she had round there? Christ, once those legs are spread they don't snap shut in a hurry…

MRS REYNOLDS: Just – I expected better. From you.

JAY: And why the hell would you do that?

MRS REYNOLDS looks at him: then turns away, defeated. Pours herself a drink, offers the bottle to JAY – he indicates no.

MRS REYNOLDS: Well then fine.

JAY: *(Of the carrier bag.)* This stuff is all crap, you can bin it.

He puts the carrier bag down on the table.

JAY: So I'll be off.

MRS REYNOLDS says nothing.

JAY: See you then. But probably not.

He starts to move off.

MRS REYNOLDS: Hold it a sec.

JAY: I knew there was something going on. What, Mel's on her way over is she?

MRS REYNOLDS: No, nothing like that.

JAY: You're gonna try and talk me into taking her back?

MRS REYNOLDS: I don't know that she'd have you.

JAY: What, then?

MRS REYNOLDS gets up. Moves to some drawers.

MRS REYNOLDS: I was having trouble,
With my hand, and then my leg.

JAY: Trouble how?

MRS REYNOLDS: The strength going in my hand.
My leg giving way underneath.

JAY: Don't mean to be rude but
You are getting on a bit.

MRS REYNOLDS: That's what I thought –

(Beat.)

In fact no I didn't.

She opens the a drawer, gets out a big envelope.

MRS REYNOLDS: I was at the doctor,
I had a bit of a throat infection.
It was Dr Kabeer and you know
She's such a sweetheart, she said,
Is there anything else I can help you with?

From the envelope she pulls loose printed sheets and pamphlets.

Hands them to JAY.

MRS REYNOLDS: This is going to be horrible for you.
I'm sorry.

MRS REYNOLDS sits back down.

JAY scans quickly through the sheets, looking at MRS REYNOLDS every now and again as he reads. She sips at her drink.

JAY: So – obviously this is what you've got.
Motor neurone disease.

MRS REYNOLDS nods.

JAY: It says there's no cure. You die.

MRS REYNOLDS: Yes.

He sees that she is watching his reaction.

And the tosses the papers down onto the table.

JAY: Tough break.

MRS REYNOLDS: That's all you've got to say?

JAY: People die on the streets all the time.
And a lot younger than you, Mrs R.

MRS REYNOLDS: We're back to 'the streets' are we?

JAY: The streets is where I live.

MRS REYNOLDS: You live with your nan!

JAY: I sleep there: I don't live there.

MRS REYNOLDS: Jay.
I've got months left.

JAY: Okay.

MRS REYNOLDS: What will happen
What could happen now quite quickly
Is that my muscles will waste away.
I won't be able to do things for myself.
Soon I'll take my last step.
I'll be hoisted
Onto the toilet.
The spit will be sucked from my mouth
So I don't drown.
A machine will breathe on my behalf.
And through all that
My mind
Will be untouched.
I will know
Everything that happens to me.

JAY: Sounds bad, yeah.

MRS REYNOLDS: I'm not brave enough, Jay.
I need help.
I need a way out.

JAY: *(Beat.)* What?

MRS REYNOLDS: I've tried a few times.
But I don't get it right.

She looks at him.

MRS REYNOLDS: I want you to help me die.

JAY: Me?

MRS REYNOLDS: Please.

JAY: And – why me?

MRS REYNOLDS: Who else would I ask?

JAY: Your kids?

MRS REYNOLDS: Too far away.

JAY: They couldn't get on a plane?

MRS REYNOLDS: It'd break their hearts.
 Because they care about me.
 They love me.

JAY: But if I help you die –

MRS REYNOLDS: You would just leave. Afterwards.
 No-one would know you were here.

JAY: Hold on hold on hold on.
 You've known for ages.

MRS REYNOLDS: Yes.

JAY: And you kept it secret?
 And you're telling me tonight
 What, to punish me?

MRS REYNOLDS: Should I have not told you at all?

JAY: You should've said sooner.
 I could've got used to it.
 That is so selfish.

MRS REYNOLDS: Probably it was selfish.
 Probably you're right but
 I'm dying, Jay.

Perhaps I need to be selfish now.
Just to get through it.

JAY: You can't – announce it out of nowhere.
You can't just say, oh by the way,
I'm dying, and I want you to help me
Kill myself, and thanks very much
For popping over. That's not –

(Beat.)

Is it a trick?

MRS REYNOLDS: No.

JAY: Some sort of lesson?
You're gonna scare me shitless and then
I'll say I'll be nice and be good and
At the last minute it's all pretend –

MRS REYNOLDS: I kept it to myself because
I wanted to be free of it.
Some conversations, a few moments
When I could just think about
Getting on with life.

JAY: This isn't the world.
Little old ladies don't sit
In their little old houses
Thinking about how to top themselves.

MRS REYNOLDS: I went to a consultant
There were examinations to see
How quickly the disease was taking hold.
The news was – not good.
On the bus, I was starting to panic,
About to cry, thinking,
Get home, get into the garden,
Get to work and you'll be fine and then –
From the end of the street I could see
Something not right.
Desi came out of the shop

He'd spotted some thug on his CCTV
He'd caught the little shit
Sat on him till the police arrived.

(Beat.)

And you had destroyed everything.
Every plant stamped on, kicked to pieces.
The roses were too tough so you just
Tore every flower off.

(Beat.)

I went in.
I curled up and
I howled
For my dead mum, my dead dad,
My dead husband.
They are all gone.
You –
You owe me.

JAY: No no no.
What we'll do is –
– I'll look after you.

MRS REYNOLDS: You will?

JAY: This is it.
This is what I'll do.

MRS REYNOLDS: No.

JAY: I'm offering.
I'll look after you.
Not a stranger. Someone you know.
Someone you can trust.
I'll do everything – how you want it.
I'll move in. It'd be great. It'd suit me.
My nan's gonna chuck me out any minute –

MRS REYNOLDS: You'll feed me,
Wash me,

Take me to the toilet.
Wipe my backside.
You will?
You?

(Beat.)

Alright.
Tell me you can do that.
Look me in the eye.

JAY: I will.
I mean,
I'll try.
I'll do my best.

She looks at him.

MRS REYNOLDS: Your best isn't good enough, I'm afraid.

JAY: If it was someone else.
Someone better.
Would you say yes then?

MRS REYNOLDS: But you can help me.
Stay with me, and
After I pass out – make sure.

JAY: What d'you mean, make sure?

MRS REYNOLDS: You know.

JAY: Not a chance.

MRS REYNOLDS: It would be a kindness.

JAY: This is wrong. You know it is.

MRS REYNOLDS: I've tried already. Got the pills. Stacks of
them.
Drop of Scotch to wash them down.
Couldn't do it. I just sat there, crying.

JAY: Doesn't that show
You don't really want to die?

MRS REYNOLDS: I don't want to die, at all!

JAY: I thought – maybe you were thinking
 Of heaven, or seeing your husband?

MRS REYNOLDS: I don't believe in any of that nonsense!

JAY: Well I don't know, do I…

MRS REYNOLDS: I could live
 For another thirty years, by rights.
 I should have decades in me.
 Want to die? Are you mad?

 (Beat.)

 But I am dying.
 Whether I like it or not.

JAY: Look. Look. Look.
 Can you say you are
 A hundred per cent sure
 This is the right thing to do?

MRS REYNOLDS: Of course I'm not.

JAY: So – you admit you might be wrong?
 Doesn't it make sense
 To wait until you're sure you're right?

MRS REYNOLDS: I'm afraid, Jay, this is how it is,
 Being an adult. You make decisions,
 Half the time you haven't got a clue
 If what you're doing is right or not.

JAY: So you're taking
 The easy way out.
 You're not going to fight?

MRS REYNOLDS: I'm going to kill
 Rather than die. So I think
 I must be fighting. Mustn't I.

JAY: When are you going to do it?

MRS REYNOLDS says nothing.

JAY: Tell me.

MRS REYNOLDS: The second you leave.

JAY: Tonight?

MRS REYNOLDS: I'm getting weaker every day
And I can't risk it, I can't risk
Getting caught.

JAY: This is insane.
You could have months yet, you said…

MRS REYNOLDS: What I have hated most
In all the years since my husband passed.
Is falling asleep on my own.
I'm lost.
I'm absolutely bloody terrified.
And I'm alone.
I wish I had someone.
But I don't.

JAY: Is that really how you feel?

MRS REYNOLDS nods.

JAY: I'll stay.

MRS REYNOLDS: What?

JAY: If you're going to do it, tonight.
If you've made up your mind.
I'll sit with you
Till you fall asleep.

MRS REYNOLDS: And then?
Will you make sure I've gotten away?

JAY: Mrs R…

She collects herself.

MRS REYNOLDS: Right. Right then.
I'll go and –

JAY: You want me to come with you?

MRS REYNOLDS: I can't have you watch me taking the pills.
If you watch me, I won't be able to do it.
So will you stay here?

JAY: Yes okay.

MRS REYNOLDS: And you'll still be here when I come back?

JAY: Of course. Are you alright?

MRS REYNOLDS: You keep bloody asking me that, and / of
course [unsaid: I'm not]

JAY: / I don't know what else to say!

MRS REYNOLDS: Just, think before you speak. It's a good
general rule.

(Beat.)

I'll go and do it then.

MRS REYNOLDS goes.

JAY is left on his own.

Gets quite upset for a bit.

Collects himself.

He stops: listens.

JAY: Are you alright?

(Beat.)

Mrs R?

Footsteps approach.

JAY: Are you, alright? *(For having asked, again.)* Sorry.

MRS REYNOLDS: I'm fine, thank you.

She hesitates for a moment, steadies herself. She is wearing the pearl necklace she planted in JAY's jacket.

JAY: Nice necklace.

MRS REYNOLDS: Only decent bit of jewellery I've got.

Mrs Reynolds reaches for the bottle.

MRS REYNOLDS: I know you don't like whisky, but –

JAY: No, I'll have some.

MRS REYNOLDS pours.

Sits down.

Lifts her glass.

MRS REYNOLDS: Cheers.

They clink glasses, drink.

JAY: How long will it take?

MRS REYNOLDS: Don't know.
Probably depends how quick
I polish off this Scotch.

She knocks back her glass. Refills.

JAY: Will you tell me things?

MRS REYNOLDS: What sorts of things?

JAY: I don't know the first thing about you.

MRS REYNOLDS: You know my name.

JAY: And that's pretty much it.

MRS REYNOLDS: We've always had other things to talk about.

JAY: Me? And my stupid life?

MRS REYNOLDS: You, for one thing.
The right way to plant a bulb, for another.

JAY: I don't know − where you grew up.

MRS REYNOLDS: A farm.

JAY: In the country?

MRS REYNOLDS: In Wales.

JAY: You're Welsh? You haven't got an accent.

MRS REYNOLDS: I left thirty years ago…

JAY: What was it like?

MRS REYNOLDS: It was like −
− time was different then.

JAY: How?

MRS REYNOLDS: In spring you'd be sowing for that year's
crops.
And there'd be lambing, and calving.
In summer there were shows,
And sales, and marts.

JAY: What's a mart?

MRS REYNOLDS: A market. Where you buy and sell animals.

JAY: You had animals? What kinds?

MRS REYNOLDS: Cows and sheep. Cows for beef, not dairy.
Geese. Hens for eggs.
Dogs, you know, collies, working dogs mostly but
I had a pet, a terrier cross called Susie. Used to
Sleep on my bed, mum hated that. Then cats in the barn,
Dozens of them, more or less wild, to keep
The rats down. We had
A few pigs one year but
Dad didn't much like them.

JAY: What was wrong with pigs?

MRS REYNOLDS: Ever tried slaughtering one?

JAY: I can honestly say I have not.

MRS REYNOLDS: They scream.
It's not something you want to hear.

JAY: I'll take your word for it.

MRS REYNOLDS: Didn't put me off the sausages, though.
Then there'd be harvest, baling the hay,
Getting the bales stacked in the barn.
Everyone would come and help,
Aunties, uncles, cousins, neighbours.
So many people in the fields, and these huge meals,
Everybody loading up their plates in the kitchen,
Going out into the garden to eat
Cause there wasn't room in the house.
Then in the autumn – ploughing, preserving.
Blackberrying, fingers stained from juice
And if you weren't careful of the thorns, blood.
Blackberry and apple tart, with loads of sugar
The warm smell from the shed
Of Dad cooking up his homebrew.
Then winter. Sharp air, smoke drifting from chimneys.
Wringing the geese's necks, then feathering them.
Splitting logs, drying socks on the Rayburn.
Christmas: asking the tree's permission
Before you cut down the holly. Climbing up a rowan for
mistletoe.
New Year, and tinkers coming up from Devon,
Mostly in vans but some still with horses and carts,
Swapping our goosefeathers for sacks of apples.
And then – this time, the worst time,
The dead months when Christmas is gone
But winter's still dragging on.
But you get through because you know
In the end, spring will come.

(Beat.)

It was like the year had a story to it.
You always knew where you were.

JAY: It sounds amazing.

She indicates the Scotch.

MRS REYNOLDS: Pour us a bit more.

JAY does as he's asked. MRS REYNOLDS takes a drink.

MRS REYNOLDS: My Dad. Now there was a man.
Firm, you know, took no nonsense but
Men in those days could get away
With a lot and
Well he never did.

JAY: They get away with a lot these days too.

MRS REYNOLDS: Yes I know.

Beat.

MRS REYNOLDS: The one thing you could do
Would really make him angry was to say,
You didn't care. If I was having an argument
With my brother and Dad heard me saying,
'I don't care,'
He'd be in there like a shot.
He'd say, you must always care. You must.

She stops.

MRS REYNOLDS: I might
Prefer to lie down, I think.

She moves onto the couch. JAY helps her arrange cushions behind her head.

JAY: That okay?

MRS REYNOLDS: Fine.

She drinks. Coughs slightly. Recovers herself.

MRS REYNOLDS: I remember when I was about ten
I started getting these terrible headaches.
Migraines I suppose. I'd be seeing colours,

Throwing up, I'd have to lie in a dark room,
Crying from the pain.
And the worst thing was I could feel it begin.
I could feel the aching start, and
As it got going I knew nothing could be done
I would just have to suffer it.
Then once Dad was home in the day,
I felt one of these headaches come on.
I started crying straight away, not
Because of the pain but because of
The pain that was on its way.
Dad sat me down, on the floor,
He sat in a chair behind me,
And he stroked my hair,
Tugged at it, gently, ran it
Through his fingers, pressed down
On my forehead and my –
– so gentle. And whispering something, I think.
And kept on. Might've been ten minutes
Might've been an hour. And eventually
I fell asleep. When I woke up,
The headache was gone.
I swear it was a miracle.
And those two days when I should've been in bed
Crying and being sick –
– it seemed like everything was perfect.

(Beat.)

He never did it again though.

JAY: Why not?

MRS REYNOLDS: No reason, it just
Never happened that way.
He was in the fields when the headaches came.
Or he'd be busy and he'd have to stop
After a minute. My brothers would be around,
Clamouring for attention.

Beat.

JAY: I could stroke your hair for you.

MRS REYNOLDS: Would you?

JAY: I won't be as good as your dad.

MRS REYNOLDS: Oh I'd love that.

JAY: Right. Well.

MRS REYNOLDS sits up slightly on the couch, so her head is resting on the couch's arm.

JAY: Okay.

He fetches a chair, sits down behind her.

And very gently, begins to stroke her hair.

MRS REYNOLDS: Sorry if it's a bit greasy.

JAY: It's fine.

He tries rubbing her scalp.

MRS REYNOLDS: Oh that's lovely...

JAY: Good.

MRS REYNOLDS: I could just float off.

JAY stops stroking her hair.

MRS REYNOLDS: Oh...

JAY: There's just
A couple of things more
I want to ask you –

MRS REYNOLDS: But it's so nice...

Beat.

JAY begins stroking her hair again.

MRS REYNOLDS: Don't feel you have to carry on.

JAY: I don't.

MRS REYNOLDS: I mean if your hands get tired.

JAY: They won't.

MRS REYNOLDS: They will in the end.

JAY: I don't think so.
You just −
− you go to sleep now.
If that's what you want.

JAY keeps on stroking her hair.

He stops.

Stands.

Looks at her.

JAY: See this is stupid.
Cos I could do this.
I could.
I could look after you.

MRS REYNOLDS is still.

JAY: I could though.

Something changes in him.

JAY: I could.

He stands for a second. Then he rushes to her.

JAY: No no no, Mrs R!
Mrs R, wake up!

He gets out his phone, dials.

JAY: *(On his phone.)* Yeah, hello?

Yeah I need an ambulance.

The planter.

A crisp day in early spring. Beautiful golden sunlight.

JAY arrives with a bag, and a few tools.

Hanging around his neck is what looks like a mobile, but is actually a cheap, short-range walkie talkie.

Gets out a bin bag and starts picking up litter from the planter.

MEL enters from the other side.

MEL: Alright.

JAY: I'm great. Yourself?

MEL: Fine. *(Beat.)* Are you? Really?
You look a bit tired.

JAY: I am a bit.

MEL: It's nice – that you're still doing all this *(Looking after the planter.)*

JAY: What was I, just gonna stop?
Any time you feel like lending a hand, though...

MEL: Yeah, maybe I will.

But JAY isn't paying attention – he's distracted by something from off

JAY: Oh, will you ever learn...

MRS REYNOLDS arrives. She's in an electric wheelchair, which she controls with a joystick. She has a walkie-talkie round her neck, just like Jay.

JAY: I told you to buzz me if you wanted to come down.

MRS REYNOLDS looks at him.

JAY: And don't give me that look – one wrong move and you'll be off that thing and in the gutter.

MEL shifts to be a bit more in MRS REYNOLDS' field of vision.

MEL: Hiya, Mrs R.

MRS REYNOLDS looks at her.

MEL doesn't know what to do. Waves, a bit limply.

JAY: *(To MEL.)* She's not big on conversation without her computer. But you can fill in her side just by imagining the grumpiest possible thing a human being could say. *(To MRS REYNOLDS.)* Isn't that right?

MRS REYNOLDS looks at him.

JAY: Mrs R, I'm shocked!
(To MEL.) You don't often hear that sort of language from an old lady.

MEL: Anyway – I best be off.

JAY: Oh – okay.

MEL: Nice to see you, Mrs R.

MEL leaves.

JAY and MRS REYNOLDS watch her go.

Then JAY looks to MRS REYNOLDS.

JAY: I know, I know.
The thing with Mel is – this time I'm playing the long game.
I'm just gonna reel her in, you know, step by step.
She won't even know it's happening.
She'll just wake up one day and realise
She can't live without me.

MRS REYNOLDS shifts her chair slightly.

JAY: Do you want me to – yeah?

JAY manoeuvres the wheel chair so it's next to the bench.

JAY: Look, you've got a bit of –

He gets out a tissue and gently, gently, wipes saliva from the side of her mouth.

He sits on the bench next to her.

JAY: Those cuttings I had off your roses?
All taken. Every last one.
And when me and Mel are back together,
And we get ourselves a little house
In some dump up north,
They will be the first things I plant.

She lifts her hand from the joystick.

He takes it.

JAY: I know we're getting close to the end now.
I know it's getting really hard.
Just the sweet peas from the autumn are budding.
They're going to flower tomorrow, the day after.
Be great if you could stick around for those.

(Beat.)

But if you've had enough.
If today's the day you want it to end –
He can't say any more, just looks for her response.
The tiniest shake of her head.

JAY: No?
No.
You can manage another day?

He watches her again. No motion this time – he sees the answer in her eyes.

JAY: Yeah. Me too.

He sits back, a huge weight lifted.

JAY: Look at it.
Will you look at it.
What a morning.

THE END.

By the same author

A Soldier in Every Son – The Rise of the Aztecs
Luis Mario Moncada
translated by Gary Owen
9781849434706

Perfect Match
9781783190607

Blackthorn / In the Pipeline
9781849430708

Love Steals Us From Loneliness
9781849430548

Iphigenia in Splott
9781783198917

Violence and Son
9781783198931

WWW.OBERONBOOKS.COM

Follow us on www.twitter.com/@oberonbooks
& www.facebook.com/OberonBooksLondon

www.ingramcontent.com/pod-product-compliance
Ingram Content Group UK Ltd.
Pitfield, Milton Keynes, MK11 3LW, UK
UKHW020736280225
455688UK00012B/696